The *Drawing* Season

JOHN MICHAEL KOHLER ARTS CENTER | SHEBOYGAN, WISCONSIN

Established in 1967 by the Sheboygan Arts Foundation, Inc., the John Michael Kohler Arts Center is nationally recognized for its nurturing of artists in the creation of new work; for its concentration on art forms, artists, and ideas that have received little critical attention; and for its ability to involve underserved audiences as well as the general public in innovative programming that helps realize the power of the arts to inspire and transform our world. Each year, Arts Center programming includes up to twenty-five exhibitions curated by staff; six performing arts series; Connecting Communities commissions to create major new works by national dance companies, composer-musicians, visual artists, filmmakers, and other artists in collaboration with the region's youth and adults; Arts/Industry, an internationally renowned residency program providing opportunities for artists to create new bodies of work and public commissions using the technologies and facilities of an industrial pottery, foundry, and enamel shop; a wide variety of educational programming, from an arts-based preschool and a hands-on drop-in program for families to national conferences; and rollicking special events.

John Michael Kohler Arts Center
608 New York Avenue
Sheboygan, Wisconsin 53081
920.458.6144 | www.jmkac.org

Designer: Wilcox Design

Photo Credits:
63–65. Photo: courtesy of the artist; 18–22. Photo: courtesy of the artist and the Ellen Miller Gallery, MA; 24. Photo: courtesy of Cavin-Morris Gallery, NY; 26. Photo: courtesy of the artist; 28. Photo: courtesy of Tom Powel, Robyn O'Neil, and Talley Dunn Gallery; photographer: Tom Powel; 10–11. Courtesy of the artist and Tanya Bonakdar Gallery, NY. Photo: courtesy Burke Studio. 34; 37–38. Photo: courtesy of the artist and Bernice Steinbaum Gallery, FL.

John Michael Kohler Arts Center Staff Publication Team
Project Manager: Christine End
Editors: Patricia DuChene and Carol Myers
Photography: Jeffrey Machtig
(unless noted above)

Library of Congress Cataloging-in-Publication Data

ISBN 978-0-9710703-9-4

The drawing season / essays by Amy Chaloupka, Alison Ferris, Leslie Umberger.
pages cm
Published on the occasion of The Drawing Season series of exhibitions by Alison Ferris, Amy Chaloupka, and Leslie Umberger, and presented by the John Michael Kohler Arts Center, Sheboygan, Wisconsin, February 19 through September 2, 2012.
ISBN 978-0-9710703-9-4
1. Drawing, American—21st century.
I. Chaloupka, Amy, author. II. Ferris, Alison, author. III. Umberger, Leslie, author. IV. John Michael Kohler Arts Center, issuing body.
NC108.2.D73 2012
741.973'07477569—dc23
2012016120

The *Drawing* Season

Contents

Acknowledgments

Artists worldwide are expressing a renewed excitement about drawing. A series of six John Michael Kohler Arts Center exhibitions, collectively THE DRAWING SEASON, illuminates the vitality and varied vocabulary of drawing within the greater sphere of contemporary art. From miniature works of graphite on paper to enormous and complex site-specific installations in unconventional materials, this invigorating series offers an opportunity to experience this time-honored practice as both comfortably familiar and startlingly new.

The support of many individuals and organizations has been critical in seeing this ambitious project through to fruition, and the Arts Center extends its deep gratitude to all. The National Endowment for the Arts (NEA) and the Wisconsin Arts Board (WAB), with funding from the State of Wisconsin, have been of significant help with THE DRAWING SEASON exhibitions, artist residencies, and other related educational programming. The NEA's and WAB's support of Arts Center endeavors, year in and year out since the mid-1970s, is greatly appreciated. The Elizabeth Firestone Graham Foundation has generously donated to the production of this catalogue, as have Zoë and Joel Dictrow, Audrey B. Heckler, Karol Howard and George Morton, and Mark Pollack.

Anchoring the exhibition series is *The Line Unleashed*, featuring five commissioned installations that free the traditional line from the confines of a single picture plane and ask viewers to reconsider their expectations about drawing. The Arts Center thanks the artists in this exhibition for their thought-provoking creativity, dedication, and many, many hours of work: Dave Eppley (NY), Anna Hepler (ME), Caroline Lathan-Stiefel (PA), Rita MacDonald (NY), and Heeseop Yoon (NY).

The highly detailed and exquisitely executed drawings of Iowa artist Timothy Wehrle invite viewers to consider the dynamics and dramas that define contemporary life in *Timothy Wehrle: I Don't Understand You and I Never Will*. This exhibition—the artist's first major solo exhibition in a museum venue—features a series of ten drawings, *The Believable Households* (2010), recently gifted to the Arts Center by the Kohler Foundation, Inc. (KFI). Our deep thanks are extended to the artist and Cavin-Morris Gallery for the pivotal role they have played. Also key were the private lenders who generously made available works from their collections: Martina Batan, John H. Friedman, Timothy S. Garvey, Audrey B. Heckler, John and Susan Jerit, Leslie Pollack, Mark Pollack, Jane Bohan and Jean de Segonz, Elizabeth Stern, Siri von Reis, and John Zorn.

In *Laylah Ali: Note Drawings*, the Massachusetts artist uses bright colors, text, and a cartoonlike style to draw viewers into works that take aim at society's complacent attitude about violence and oppression. Her images, evidencing hand-drawn marks and intimacy of scale, remind us that the very act of drawing can be radical and transforming. For making this series of thirty-seven drawings available, we express our appreciation to the artist and Ellen Miller Gallery.

4

Viewers experience the power of hand-rendered drawings of immense proportions in *Chris Hipkiss and Robyn O'Neil: A Chill in the Air*. Hipkiss, a British artist living in France, spent two years working on the largest piece in the exhibition series, a 5-by-35-foot drawing exploring a curious evolution of species. This powerful work and others in the exhibition were generously donated to the Arts Center several years ago by KFI. California artist O'Neil creates spaces seemingly so vast one could be sucked into their vortices, and, like Hipkiss, she ponders the fate of humans and the planet. Making this astonishing work available for public viewing required the generosity of many, and we thank the artists, the Blanton Museum of Art at the University of Texas at Austin, the Kemper Museum of Contemporary Art, the Linda Pace Foundation, Cavin-Morris Gallery, Audrey B. Heckler, Karol Howard and George Morton, Elizabeth Stern, Anthony Terrana, Tony Wight, and an anonymous lender. Special appreciation goes to Talley Dunn Gallery and Susan Inglett Gallery for helping to bring this exhibition to fruition.

Paul Chiappe of Scotland and Peggy Preheim of New York draw viewers in close with works of art that are classically rendered and minute in scale. In tremendous contrast to works by Hipkiss and O'Neil, the drawings in this exhibition might best be seen under magnification. Using personal, found, or historical photographs as their starting points, both artists depict the figure in impossibly detailed drawings, altering elements to enigmatic ends. We sincerely appreciate all the artists did to help bring *Paul Chiappe and Peggy Preheim: Quiet Accord* together, as well as the lenders who shared their work: Deborah Davis, Hamilton Corporate Finance Ltd., Madder139, Lea Weingarten, and an anonymous lender.

In *Carol Prusa: Optic Nerve*, classic skills, materials, and techniques converge with unconventional presentation and hi-tech mixed-media. Working predominantly in the ancient technique of silverpoint, Florida artist Carol Prusa's strong interest in science and background in bio-communications and medical illustration informs elegant, domed works that explore the wonders of both macro and micro worlds. The artist and Bernice Steinbaum Gallery were instrumental in bringing this exhibition to fruition; we express deep gratitude to them.

The Arts Center's curatorial staff is central to putting together an exhibition series such as this one: powerful, provocative, and pleasing. Particular thanks to the lead curator of this series, Alison Ferris, as well as Senior Curator Leslie Umberger, and Assistant Curator Amy Chaloupka, and the entire exhibitions team—Larry Donoval, Erik Hansen, James Milostan, Matt Terrell, Jo Bjorkman, and Christine End—who make such exhibitions come to life, engaging audiences throughout the country.

The Arts Center staff as a whole makes the exhibitions far more meaningful and allows them to reach exponentially greater audiences through educational programs, artists' residencies, and a variety of related events. The sustained commitment and involvement of the Friends of Art docents and other volunteers as well as our Board of Directors and Community Partners is of critical importance in making the broad range of programming possible.

Ruth DeYoung Kohler
Director, John Michael Kohler Arts Center

Paul Chiappe and Peggy Preheim | Quiet Accord
Amy Chaloupka

--

Artists Paul Chiappe (Scotland) and Peggy Preheim (NY) use pencil on paper to create delicate and powerful drawings that, upon first glance, scarcely whisper from across the room. Many of the works measure no larger than a postage stamp, and the compact details are most fully revealed with the aid of a magnifying glass. Beyond a fondness for simple materials and an interest in working on seemingly impossibly minute scales, both Chiappe and Preheim explore the figure through mysterious narratives and draw inspiration from the imagery of bygone eras.

Paul Chiappe's tiny drawings utilize images primarily found on the Internet. While they may look like perfect copies, he subtly alters each original by piecing together imagery from several photographs or injecting elements of popular culture into presumably historical scenes, creating an uneasy or uncanny feel. Underscoring his photographic sources, Chiappe masterfully replicates the illusion of processes specific to the camera, using pencil to create intentionally blurry scenes that evoke shallow depth of field and other in-camera effects. What appears to have been captured in a flash actually took Chiappe several months to achieve.

Peggy Preheim uses personal, found, and historical photographs culled from flea markets and antiques stores as inspiration. Her anonymous figures are precisely extracted fragments that float in a sea of white paper, nothing solid anchoring them to the page. Some figures drift dangerously close to the edge or fade into their white backgrounds, appearing vulnerable and isolated. Removed from any concrete history or defining context, the narratives that emerge are open to interpretation. Yet Preheim's titles hint at emotional forays and play on associations that add layers of meaning to her imagery.

For both artists, motifs nostalgically circle around childhood and ages gone by—those times more innocent than our own. The miniature scale draws viewers in close, offering an intimate proximity to the subtle nuances of shadow and expression, revealing glimpses of private realms and suggesting the transience of time and existence.

Preheim's *Plait* (2007) depicts a softly rendered yet oddly disembodied braid of hair; *Bee in the Bonnet* (2009) portrays a Victorian doll's, or perhaps a child's, head (it is unclear which) with a distant and empty gaze. Fuzzy and elusive,

elusive, both drawings suggest the fleeting and incomplete nature of memory. These carefully selected and conserved details from someone else's life, tenderly and precisely drawn by Preheim, serve as momentary landing spots of longing for an inaccessible past. This, coupled with the small, precious nature of the drawings, conjures the keepsake quality of mementos or nineteenth-century mourning jewelry—items that also sought to capture the essence of a lost soul.[1]

In *Untitled 27* (2008), a drawing of what appears to be a Victorian-era family portrait, Chiappe portrays two central figures—nearly identically dressed young girls—in sharp focus. By contrast, he deliberately distorts or obscures the remaining four family members' features beyond recognition. Specters within the scene, they barely cling to the surface of the paper. The composition and technique echo another mid-nineteenth-century cultural phenomenon—the "spirit photography" that was so popular in both the United States and England. Photographic tricks such as double exposure, soft focus, and composite printing facilitated the creation of scenes seemingly inhabited by ghosts. Spiritualists, the practitioners of spirit photography, promoted these images as "proven" modes of communication with the dead and offered them as souvenirs for grief stricken mourners.[2]

Chiappe's and Preheim's present-day incarnations on paper appear no less haunting and evocative than their 150-year-old counterparts. Even in an age well versed in digital image technologies, with its array of appropriative methods, their drawings provoke a sense of wide-eyed wonder, perhaps in keeping with what it may have been like to first lay eyes on the earliest captured photographs. They offer amazement as well as a voyeuristic peek inside the world of someone else's personal belongings.

Despite the melancholic moods and references to the past revealed in many of Chiappe's and Preheim's drawings, the perennial nature of simple pleasures do emerge. Chiappe frequently implants amusing elements into his drawings, for example, the sly inclusion of comedians Laurel and Hardy into a historical primary school photograph. Other favorite subjects for Chiappe are children dressed in peculiar, handmade Halloween costumes. *Untitled 45* (2010) depicts an awkward portrait of a small child, teetering under the weight of an oversized Humpty Dumpty head, who is practically shoved out of the small frame by his scene-stealing sibling.

In Preheim's *Grass Ceiling* (2008), a formally dressed man, circa the 1920s, cheerfully attempts a childish handstand on a small patch of lawn at the deckle-edged top of the page. The drawing reflects a carefree abandon normally

reserved for children at play. As in many of Preheim's drawings, the title of the piece is a play on words, in this instance literally turning the term "glass ceiling" on its head.

Childhood is a potent, paradoxical, and recurring symbol in both bodies of work, with themes of comfort and fear, the rigid boundaries of daily life and the limitless freedoms of make-believe, emotional highs and lows, playful camaraderie and quiet isolation, and discovery and loss. In Chiappe's and Preheim's drawings, the vastness of the paper surrounding the diminutive figures evokes the exposure and fragility of being a child outsized by his surroundings. They serve as a reminder that the bustling and complex world of adults can sometimes appear cold and unfriendly from a child's perspective. It is the kind of imagery that, if given time and consideration, reveals worlds both humbling and profound. In this way, they mirror the words and actions that emerge from children, who, when given similar time and consideration, delight and inspire with unmatched profundity.

Notes

1. For more on Victorian-era mourning jewelry, see Elizabeth Hallam and Jenny Hockey's *Death, Memory & Material Culture* (New York: Berg, 2001).

2. Spiritualism and spirit photography described in Tom Gunning's essay *Haunting Images: Ghosts, Photography and the Modern Body*, 8-18. Referenced in *The Disembodied Spirit*, exh. cat. (Brunswick, Maine: Bowdoin College Museum of Art).

| 1 | Paul Chiappe, *Dean Orphanage*. Cat. 1.

| 2 | Paul Chiappe, *Untitled 27*. Cat. 5.

| 3 | Paul Chiappe, *Untitled 27*. Cat. 5.

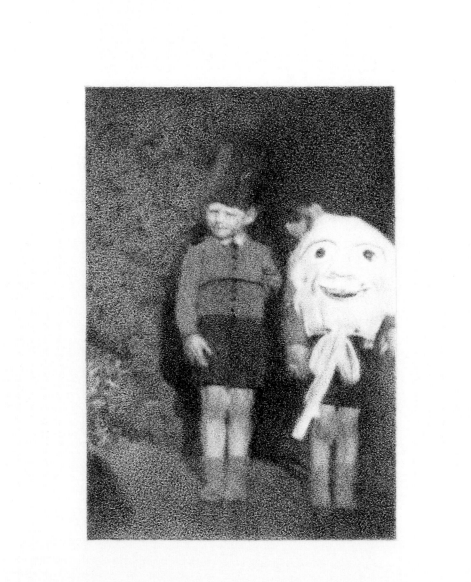

| 4 | Paul Chiappe, *Untitled 45*. Cat. 8.

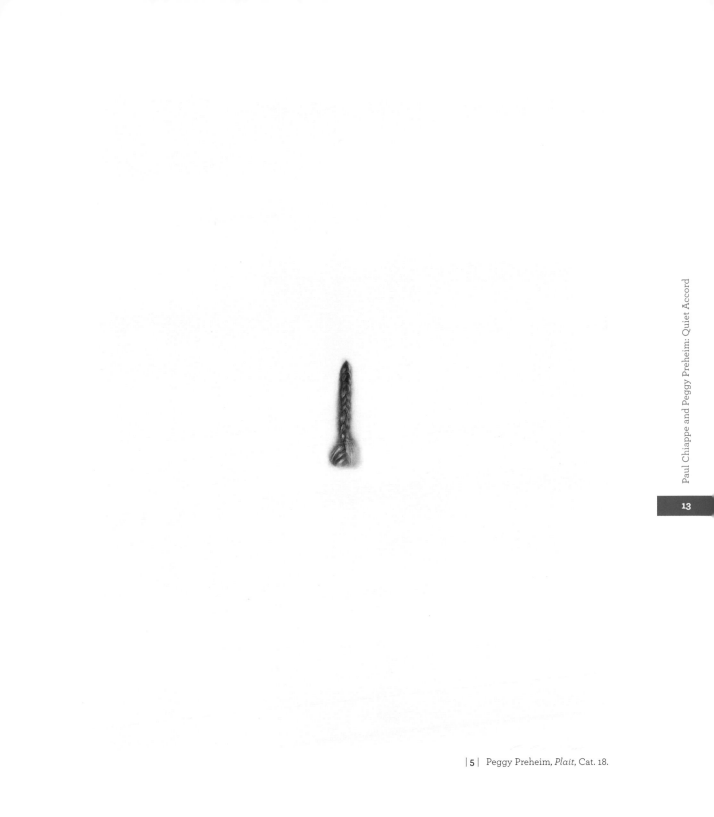

|5| Peggy Preheim, *Plait*, Cat. 18.

| 6 | Peggy Preheim, *Grass Ceiling*. Cat. 13.

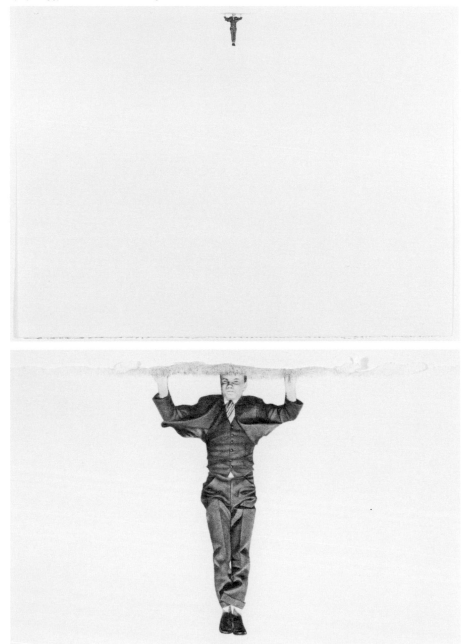

| 7 | Peggy Preheim, *Grass Ceiling*. Cat. 13.

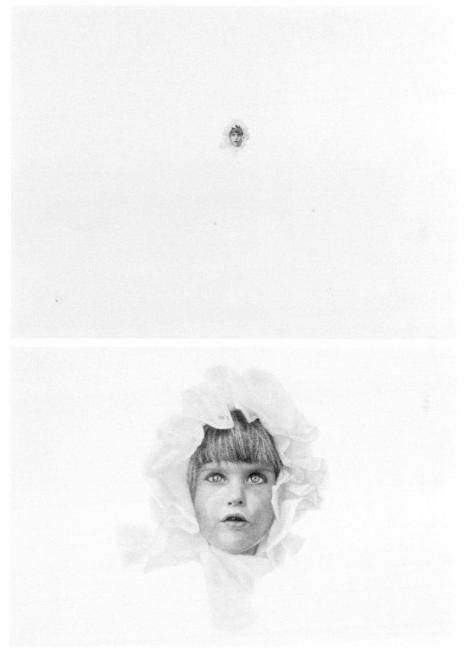

15

| 9 | Peggy Preheim, *Bee in the Bonnet.* Cat. 10.

| 10 | Peggy Preheim, *Miss Match*. Cat. 17.

| 11 | Peggy Preheim, *Hair Trigger.* Cat. 14.

Timothy Wehrle | I Don't Understand You and I Never Will

Leslie Umberger

--

The scenes of Iowa artist Timothy Wehrle teem, their color and patterning evoking illuminated manuscripts, Persian miniatures, comic books, sacred mandalas, crazy quilts, psychedelic album covers, and the kaleidoscopic drawings of Swiss artist Adolph Wölfli—yet his style and subjects remain uniquely his own. Wehrle eschewed artistic training, believing that it would quash a pure and bountiful vision.

Exploring the dynamics and pitfalls of contemporary culture, Wehrle's imagery deftly fuses an aura of charm with an undercurrent of admonition; it conveys a complex vision of humanity and poses some tough questions about civilized existence. Writer and gallerist Randall Morris has observed, "[Wehrle's] drawings poetically unwrap the concept of a Cold War of the soul in a new world where the artist-citizen is constantly acted upon by encroaching depersonalization but is able to resist and ultimately strike back utilizing dreams, visions, and art making."[1]

Executed in graphite, colored pencil, and ink he makes himself from walnuts, Wehrle's intricate images distill moments of experience like pages from a diary. His conceptual material is wide-ranging, spanning topics of lighthearted homage (to a quirky dog he saw on the street or the festive tendencies of octogenarians) to the poetry of everyday life (the mind-expanding capabilities of music, the intangibility of beauty, the complexities of love) to harsh comments on the ills of society (child abuse, poverty, Internet pornography, the divisiveness of technology, and the ultimate breakdown of human interaction).

Regardless of specifics, Wehrle's layered and flexible imagery metaphorically captures experience and memory, subjectivity and interpretation. Often casting himself as the central figure, the artist doggedly explores the evolving self within a multitasking, preoccupied, fractured, and stressed-out society gravitating toward existential poles such as intimacy and isolation, morality and depravity, autonomy and collectivity.

Born in 1978, Wehrle grew up in Burlington, Iowa. The middle child of a middle-class family in Middle America, Wehrle's perspective is indelibly marked by working-class existence. Artistic and musical from childhood but

aware that one had to somehow earn a living, Wehrle recalls telling his mother that he planned to pursue art as a career. He drew with great focus as young as age six and remembers that, even then, his finished drawings felt essential. He recalls hiding them in a cavity beneath his closet floorboards, secreted away from the invasive kids his mom minded after school.

Wehrle processed his father's disappointment when adolescence bore out the reality that he was not a natural athlete but took inspiration from his mother's creativity and the dedication she gave to her meticulous embroidery work. In spite of any superficial cohesiveness, Wehrle notes the members of his family were never close. The three kids, with six years separating each, lived independent lives. Television dominated household evenings, fostering in Tim a lasting aversion to electronic devices that engender isolation amongst people sitting in the same room.

After high school, Wehrle was encouraged to move out and make his own way. He headed north, seeking an education in English, first at a community college in Cedar Rapids and then the University of Iowa in Iowa City. Feeling the pressures of independence, Wehrle experienced, in his words: "a freak-out—a little breakdown."[2] During a several-week hospital stay, Wehrle spent the brunt of his time drawing. He realized that drawing was, for him, an overtly healthy act. Having time to think, process, and translate the workings of his mind onto paper was sustaining, fortifying. He determined to make it his primary focus.

Wehrle quit school but kept drawing, playing guitar, and reading poetry. An influential roommate was impressed with his art and began to show Wehrle the work of others: Mark Rothko, Paul Klee, and Jean Dubuffet to name a few. An image by James Ensor remains vivid: *Christ's Entry into Brussels* (1889) made Wehrle intensely aware that a drawing was not merely marks on paper, it could be a portal into another realm.

Wehrle considered the possibility that art school might suit him better than a general liberal arts program. Accepted into the Emily Carr University of Art and Design in Vancouver, British Columbia, he spent a week traveling by bus to the sight-unseen school. The orientation was numbing; the art Wehrle saw felt homogenous, and he immediately sensed that if he attended the program, it would be at the cost of his personal vision and style. He took the bus back to Iowa.

Since then, Wehrle has drawn an average of six to eight hours a day, six days a week, letting his aesthetics and techniques develop along their own trajectories. He acknowledges the tremendous role his upbringing has played, from his

morals and work ethic to his continual ruminations on what it takes to create a happy household. The house itself is among Wehrle's most potent symbols—the home as a loaded site of human interplay, flashing between matters intimate and immense.

In *Cul-de-sacs, Oooh How They Twinkle Throughout the Night* (2007), Wehrle slices open a house to investigate the scintillating light emanating from within. He finds not conversation or familial togetherness within the snug evening abode, but a compartmentalized and alienated environment populated with television-entranced zombies, the light from the TV sets creating the only movement in the room.

In *Self-portrait of the Artist Reflecting Back on a Reflection* (2009), Wehrle again explores the theme of the house. This time, the structure is a site of longing, symbolizing, for him, an unattainable dream. The artist depicts himself reaching toward a house: icon of safety, stability, family life, and love. Yet he is locked outside; as time passes, a woman within wastes away into skeletal remains. A mirror reflects the artist's own visage, and he must ruminate on the trail of isolation that has dogged him from childhood to adolescence to adulthood and wends into the foreseeable future.

In 2010, Wehrle delved deeply into the theme of the house in a series of ten drawings: *The Believable Households*. Again using the device of a cutaway vantage point, Wehrle simultaneously indulges voyeuristic inclinations and deconstructs the romanticized notion of the house as a blissful haven. In two of the houses, Wehrle explores the universal experiences of birth and death. Within the others, viewers are invited to interpret what happens in between the variously complex dynamics of everyday behavior amongst people dwelling under the same roof. A wealthy family disregards the psychological trauma of one child and the rebellion of another. A single mother struggles to provide for her child. A migrant worker pines for his faraway family. A man, unable to manage the burdens upon him, chooses death. Relationships are torn apart as individuals become consumed with, and corrupted by, electronic devices, Internet sex, and lives lived vicariously via social media and reality TV.

Commenting about *The Believable Households*, Wehrle summarized their central inquiry: "Do our houses mirror our souls?"[3] In this, Wehrle dovetails with the research of French philosopher Gaston Bachelard, whose best-known work contemplated the ways in which inhabited domestic space does, in fact, transcend the inert geometry that superficially describes it. Bachelard evokes the house as a "nest for dreaming, a shelter for imagining."[4] He called it, alter-

nately, a "bundle of images" and "a psychological diagram," suggesting that, as adults, we return time and again to "the house [that] holds childhood motionless in its arms."[5] In all of his interpersonal explorations, Wehrle seems to arrive at the same conclusion: humans are too inherently complex and changeable to ever truly know one another.

A soulful artist of tremendous vision, Wehrle wisely resists adjectives such as obsessive and outsider and their concomitant implications of dysfunction and disconnection. He has never regretted taking "a different road," setting conventions and opinions aside, and letting his art be his guide.[6] In the early years of the twenty-first century, Wehrle moved around, experiencing the varying energies of New Orleans, Louisiana; Portland, Oregon; and Seattle, Washington. In 2011, he returned to Burlington, where he currently lives on the banks of the Mississippi River. *I Don't Understand You and I Never Will* is his first major solo exhibition in a museum venue.

This essay appears courtesy of Raw Vision *magazine.* Timothy Wehrle: I Don't Understand You and I Never Will *has been slightly revised from the original, which appeared in* Raw Vision *#75, Spring 2012, with the title* Timothy Wehrle: a Nest for Dreaming, a Shelter for Imagining.

Notes

1. Randall Morris, from Cavin-Morris Gallery press release: *Entrances of Old Man Winter,* January 17–March 1, 2008.

2. Timothy Wehrle, interview with Leslie Umberger, October 26 and 27, 2011.

3. Unpublished letter to Kohler Foundation, Inc. and the John Michael Kohler Arts Center; 2011.

4. John R. Stilgoe, "Foreword to the 1994 Edition," in Gaston Bachelard, *The Poetics of Space* (Boston: Beacon Press; 1958; 1964, 1994), viii.

5. Gaston Bachelard, *The Poetics of Space* (Boston: Beacon Press; 1958; 1964, 1994), 47; 39; 8.

6. Timothy Wehrle, interview with Leslie Umberger, October 26 and 27, 2011.

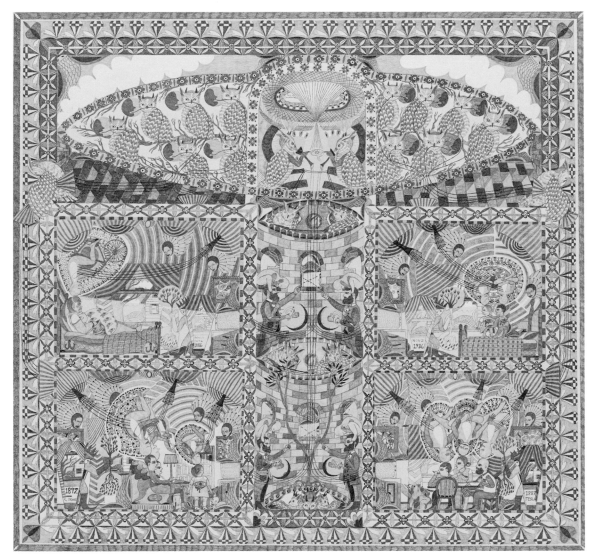

| 12 | *Culdesacs, Oooh How They Twinkle Throughout the Night*, Cat. 25.

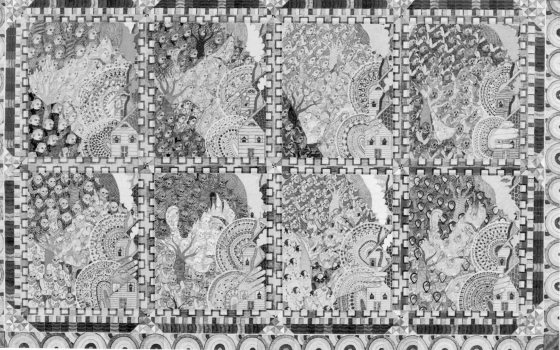

|13| *Self-portrait of the Artist Reflecting Back on a Reflection.* Cat. 40.

| 14 | *I Don't Understand You and I Never Will.* Cat. 32.

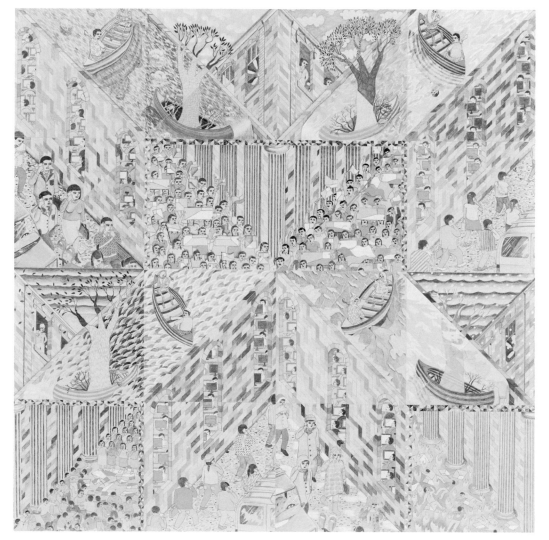

| 15 | *In the Box*. Cat. 33.

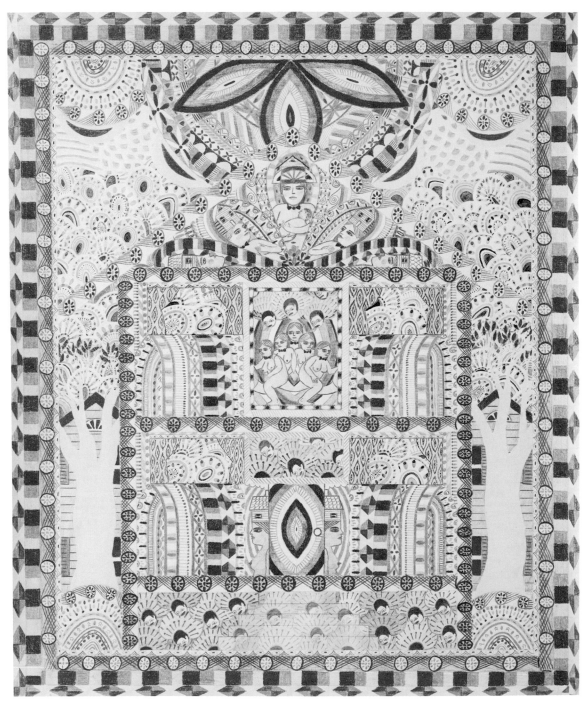

Believable Households. Cat. 24.

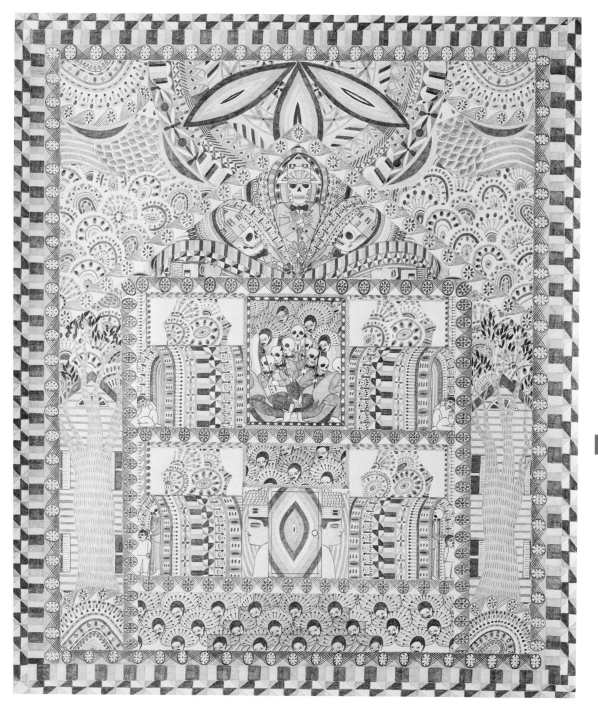

| 17 | *Believable Households.* Cat. 24.

Laylah Ali | Note Drawings
Alison Ferris

In intimately scaled drawings of figures that look, at first glance, like cartoon characters, Laylah Ali's *Note Drawings* addresses challenging issues, particularly the violence that suffuses our daily life. The Massachusetts artist's spare but provocative drawings confront the reality of being anesthetized to violence in all its forms, from racial and gender oppression and abuse to global warfare.

A cartoon drawing is economical in line and color, providing for a seemingly straightforward means of expression. Political cartoons, in particular, are astute renderings that effectively cut to the chase while retaining the complexity of a topic. For centuries, artists have used cartoon-like renderings as vehicles of satire, the most famous example perhaps being the work of William Hogarth (1697–1764), whose popular prints mocked the British ruling class during the eighteenth century.

Like a political cartoonist, Ali draws from a wide range of references—everyday life, pop culture, and high art, among others—to subversively address contemporary topics. Her imagery, however, does not neatly fit into the category of political cartooning as it lacks references to distinct events or political situations, and there are no satirical punch lines. Nonetheless, Ali's *Note Drawings* still manages to pack a political wallop.

What then makes these cartoon-like drawings so jolting? As artist Kara Walker observed during an interview with Ali: "Cartoons intimately engage their readers and captivate audiences over longer periods of time . . . The reader is taught the language of the image by its simplicity, the reduced palette, and repetitive forms in a way that brings him or her nearer to the artist." In other words, Ali uses a familiar visual vocabulary to draw viewers in and engage them with tough, shocking global issues.

Ali understands cartoons as "a kind of sign system that offers varying degrees of complexity." In *Note Drawings*, her images typify what we see regularly on the news and in print media, yet they are simplified and obscured, effectively blocking our ability to align the images with actual people or events. She uses veils, headdresses, masks, and other accoutrements to signify ethnicity and race, but the specifics of identity and culture remain ambiguous. At times, her subjects appear to be in the midst of reacting to an event—running from what

might be a perpetrator or recovering from a beating or violent accident—but the details, too, are unclear.

Like the images in *Note Drawings*, Ali's texts do not refer to specific incidents or occasions. She clips articles, headlines, and images from newspapers, and jots down bits and pieces of overheard conversations and sound bites from radio and television reports, collecting and sorting her findings. Key phrases are organized into numerical lists and handwritten, five to ten to a page. Although Ali's notes might seem randomly selected, she transcribed and arranged them with attention to poetic rhythm and syntax. The meaning of the words and fragmented phrases can be understood enough to stir sensations but never link with any particular political or cultural occasion.

These visual and textual clues comprise what the artist refers to as "implied histories," offering social backdrops and malleable narratives that individuals may interpret differently. Thus, Ali conveys that meaning is pliable and contin-

46. Secretly working on a nuclear bomb.
47. If he can do it (#13) so can I.
48. Flank pain.
49. (I have had ~~trouble~~ trouble adapting.)
50. ~~Massachusetts~~; USA.
51. A dank basement-like smell: part ~~mildew~~ mildew, part wet paint.

58. A lot less white.
59. Town hall meeting.
60. "With power, with energy."
61. Home turf.
62. Hanged in 1859.
63. "I am willing to do the following to prove it to you."
63.A Think big.
63.B Contemplate a huge + meaningful change.
64.E Die.

| 18 | *Note Drawings*. Cat. 44. | 19 | *Note Drawings*. Cat. 44.

ually shifting and that representation and language are incapable of expressing a single truth.

Finally, Ali's *Note Drawings* embodies the power of art to reveal, through fresh eyes, daily realities that often pass "unseen." The rawness, immediacy, and intimate scale of her drawings present brutality and oppression in a manner that is very different from that of most mainstream media. They confound the ease with which viewers disengage from the harsh realities of suffering when presented with mass media reports of foreign wars or natural disasters.

Ali's drawing of a broken body, a body that has endured violence and shock as a result of intense conflict, is not unlike having physical evidence laid out, in real time, up close, and personal. Her images demonstrate that, in the midst of a digital revolution, the traditional act of drawing can be radical—its precision and intentionality more startling than "real" images made with cameras. In this context, Ali's potent and careful hand renderings powerfully challenge passivity in a culture of violence.

The handwritten text within the drawing reads:

40. A friend who is an incurable narcissist.

Having to receive emails... ...above that ...wild successes.

42. Knowledge of wrong-doing from firsthand witnessing.

43. Unable to do that ...ll fight to... ...jobs.

45. Blacker than any black you have ever seen.

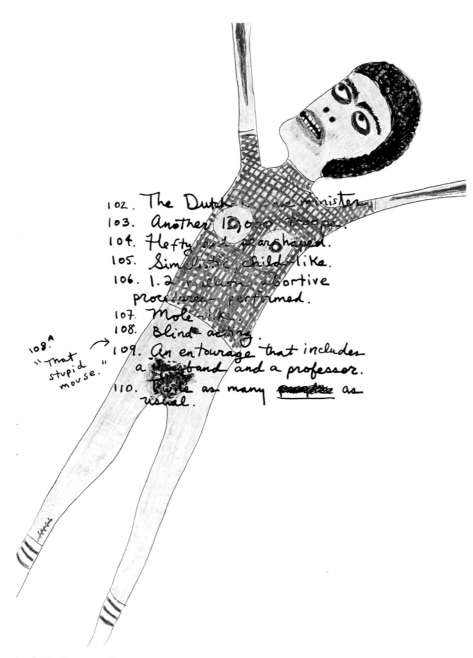

102. The Dutch minister.
103. Another 10,000 troops.
104. Hefty ... pear-shaped.
105. Simplistic child-like.
106. 1.2 million abortive
procedures performed.
107. Mole-like.
108. Blind acting.

108.A
" That
stupid
mouse."

109. An entourage that includes
a husband and a professor.
110. Twice as many ~~people~~ as
usual.

| 21 | *Note Drawings.* Cat. 44.

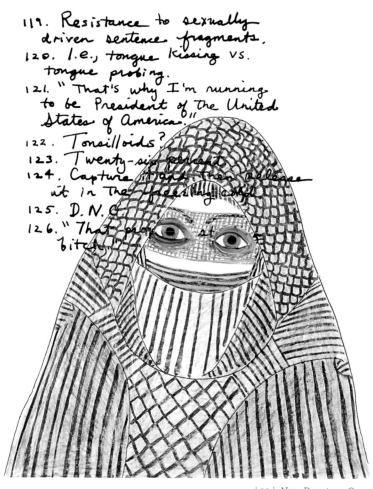

119. Resistance to sexually driven sentence fragments.
120. I.e., tongue kissing vs. tongue probing.
121. "That's why I'm running to be President of the United States of America."
122. Tonsilloids?
123. Twenty-six percent.
124. Capture island then release it in the federally camp.
125. D.N.C.
126. "That prob at bitch"

Chris Hipkiss and Robyn O'Neil | A Chill in the Air
Amy Chaloupka

In compelling large-scale drawings, Chris Hipkiss and Robyn O'Neil offer provocative commentaries on the human condition. Drawing on the age-old vehicle of narrative, each artist creates characters whose actions play out within encompassing and complex settings.

For eight years, California-based Robyn O'Neil developed a labyrinthine series portraying an epic drama of weather, wildlife, and the human race. More than once in her life, O'Neil's world has been turned upside down by natural disasters. Growing up in Nebraska and Texas, hurricanes and tornadoes were part of life's fabric. In 1983, when O'Neil was just a girl, Hurricane Alicia tore the roof off her family's home, and in 2008, the intense floods from Hurricane Ike wreaked havoc for her again. Knowing firsthand that the natural world is capable of unstoppable forces, O'Neil's comingled fear and respect are evidenced in imagery that warns against underestimating nature's wrath.

Each of O'Neil's scenes depicts an environment strangely in flux, navigated by a tribe of sweat-suited, sneaker-clad men. O'Neil initially began populating her drawings with these casually dressed middle-aged men in homage to her father. Living in an urban, college setting when she began this series—a stark contrast to her Omaha roots—she longed for the kind of "honest, regular guys" she grew up with in Nebraska. In her mind, these men embodied the archetype of humankind.

Throughout the narrative, O'Neil's figures engage in silly and mundane behaviors such as exercising, politely conversing, staring blankly at one another, or futilely attempting to connect with their surroundings. As the story unfolds, their situation becomes increasingly dire; it is apparent these hapless souls are entirely outmatched by their raw and exposed landscapes.

Chris Hipkiss grew up in a congested western suburb of London, but the oppression of this environment was punctuated by quiet weekends on his father's boat, moored on the River Thames. These moments spent away from the bustle fostered the artist's lasting connection with nature. As an adult, Hipkiss found inspiration in the lush and wild backdrop of his home in the rural Kent countryside, and later in southern France, where he currently resides. Deeply concerned with industrial development and urban sprawl overtaking natural spaces, Hipkiss's imagery evidences a struggle between these opposites on scales both immense and intricate.

In a barely recognizable future world, Hipkiss suggests a heroic tale of mutated humans negotiating a threatening, unruly, and equally mutated environment. In contrast to O'Neil's remote, barren locations and vulnerable protagonists, Hipkiss focuses on cultivated gardens and frenetic cityscapes in which the natural world has proven untamable. Like O'Neil, Hipkiss conceives of a landscape with the power to consume its inhabitants, yet the characters he enlists are up for the challenge. His valiant "androgynes"—predominantly yet not strictly feminine—endlessly attempt to conquer and survive at any cost, even if that entails merging with their hostile environs.

In *Mongrel Global 37 (Fist After the War)* (1997), Hipkiss offers the idea of a world in which the evolutionary cycle has moved along a strange and unstoppable path. In buildings that sprout foliage, birds and insects that swarm in formation like fighter jets dropping fertile ammunition, barbed-wire shrubbery, and crops of corn that on second glance might be rows of artillery shells, Hipkiss suggests that boundaries of all kinds are breaking down. However, the artist refutes a reading of his imagery as strictly a battle of feminine nature versus masculine culture, stating that his hybridized scenes do not reflect "the antagonism between masculine and feminine but the fusion of the two."

Both artists have chosen drawing as their sole endeavor, O'Neil for more than a decade and Hipkiss for more than two. Each believes this rich practice has an appropriate tenor, both in terms of style and meaning, yet their approaches are radically different.

O'Neil is obsessively clean and precise in her technique. She works with the smallest lead mechanical pencil on the largest flat sheets of commercially available paper, using this contrast to intensify the overwhelming scope and drama of the natural environment.

Working eighteen-hour days for up to eight months on a single drawing, O'Neil does not draw from life or images, but instead works inside her studio, generating imagery from memory or imagination. The soft and paunchy men populating her scenes are drawn in an intentionally awkward style; they appear tense and robotic when juxtaposed with the natural and graceful elements of the scene. The humans are clearly disconnected from their current situation while the birds, pines, elk, and blades of grass are perfectly in their element.

Anything but pristine in his practice, Hipkiss also favors a mammoth scale, comingling graphite and silver ink to heighten his effect. His 35-foot scroll, *Lonely Europe Arm Yourself* (1995), took two and one-half years and more than 350 soft pencils to complete. Embracing the smudges, fingerprints, and grime

that inadvertently become part of the scene, Hipkiss welcomes the organic nature of the process and the distinct patina of time worked into his surfaces.

His meandering compositions comprise rhythmic repeating patterns and hypnotic motifs that consume every square inch of the paper—a battalion of towers and factories with infinite grids of miniscule windows; snaking vines, metal pipes, electrical fences, and rows upon rows of corn crops that recede into the distant and high horizon.

Both Hipkiss's vast panoramas and O'Neil's tripaneled scenes echo the layered narratives and complex landscapes of Northern Renaissance painters Hieronymus Bosch and Pieter Brueghel the Elder. In her first large-scale drawing, *Everything that stands will be at odds with its neighbor, and everything that falls will perish without grace* (2003), O'Neil closely approximates the scale of Bosch's triptych *Garden of Earthly Delights* (c. 1504) and underscores the biblical connection via her own lengthy, prophetic title.

| 23 | Chris Hipkiss, *Lonely Europe Arm Yourself*. Cat. 47.

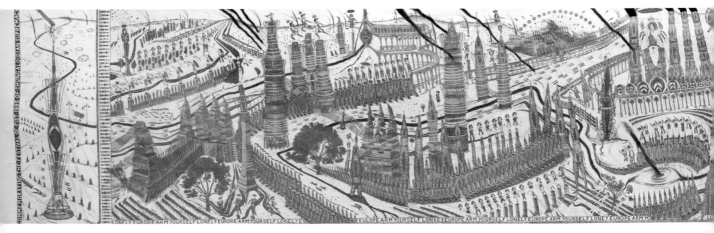

Like Bosch, O'Neil implements a high horizon line and imposing landscape, similarly depicting roiling events surrounding the fall of man; however, she strikes a distinctly contemporary chord of malaise within her perilous scenario. In this world of only men, there is no possibility for regeneration. O'Neil's apocalyptic scenes reveal the impact of global warming: swollen seas and heavy skies ready to erase all.

By contrast, Hipkiss's scenes are fertile on all fronts. His figures seem able to self-propagate, while plants, animals, and even the architecture cross-pollinate and hybridize at a frenzied pace. Hipkiss mirrors the out-of-control speed of communication and decision making in a technologically consumed society.

Although possibly suggesting doomsday scenarios at opposite ends of the spectrum, Hipkiss and O'Neil share a deep passion and reverence for the natural world that emerges through their thoughtful and dedicated renderings, offering glimmers of hope on the horizon.

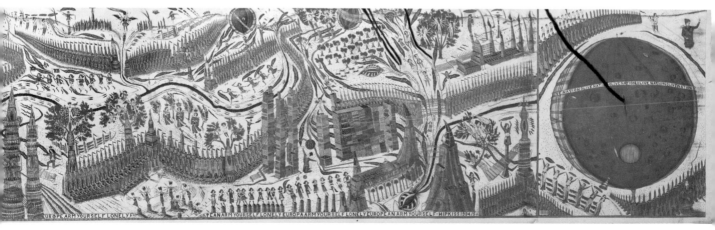

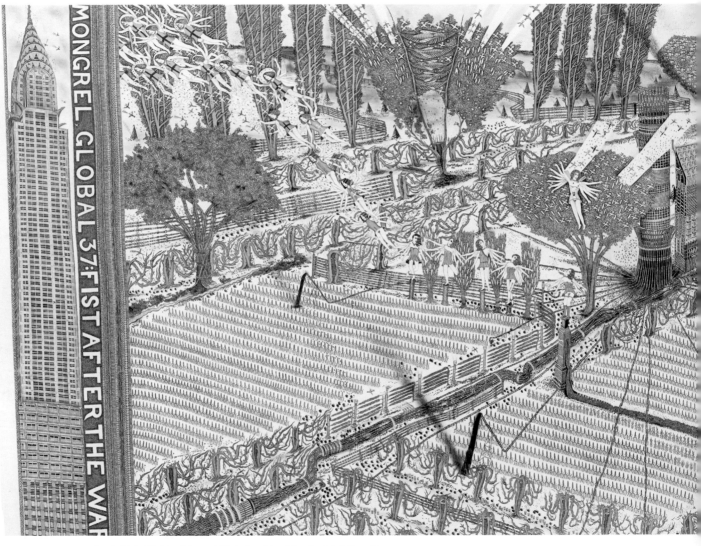

| 24 | Chris Hipkiss, *Mongrel Global 37 (Fist After the War)*. Cat. 48.

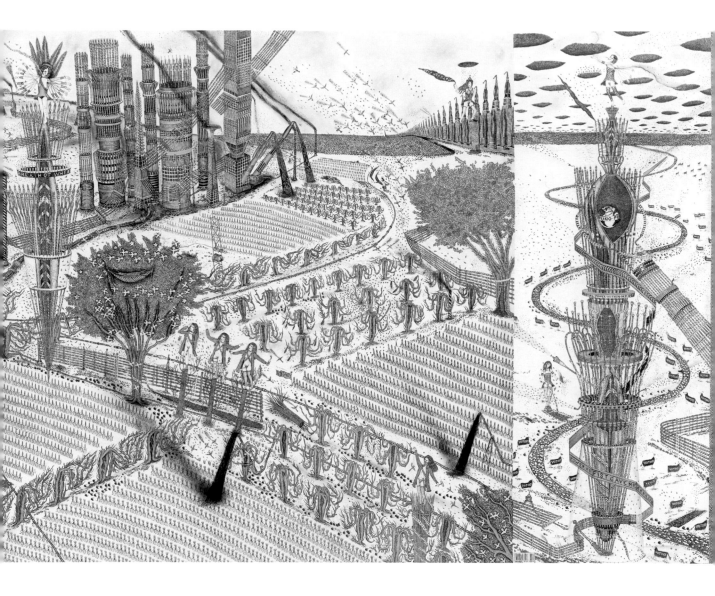

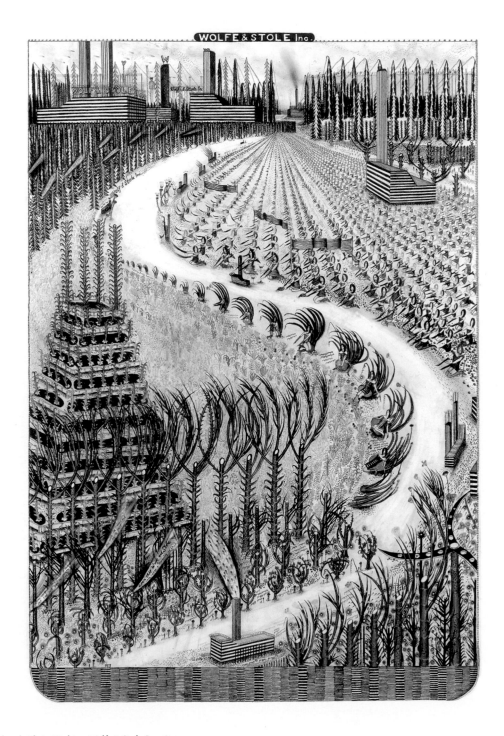

| 25 | Chris Hipkiss, *Wolfe & Stole Inc.* Cat. 51.

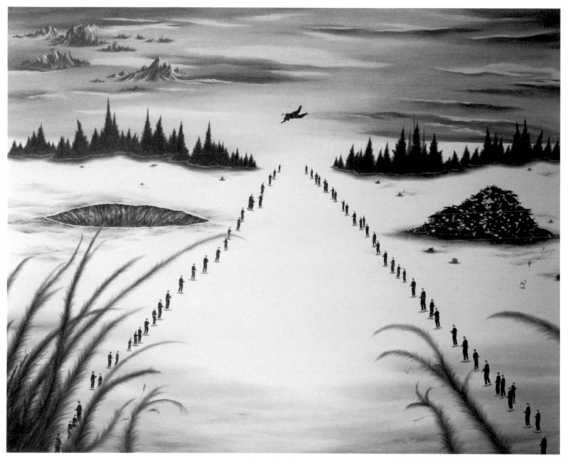

| 26 | Robyn O'Neil, *A death, a fall, a march: toward a better world.* Cat. 52.

| **27** | Robyn O'Neil, *Staring into the blankness, they fell in order to begin* (detail). Cat. 56.

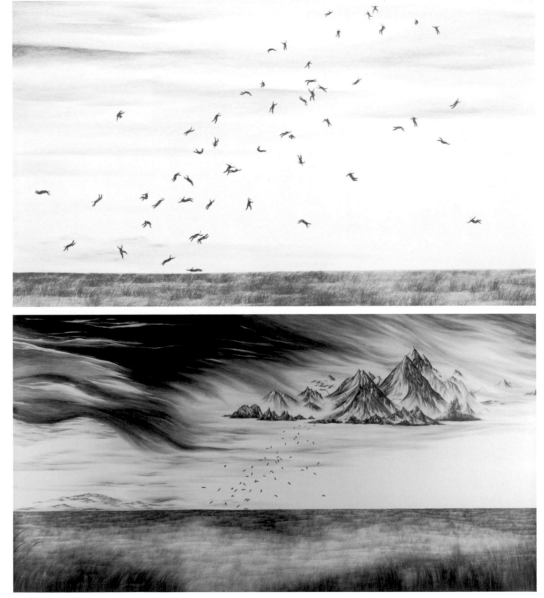

| **28** | Robyn O'Neil, *Staring into the blankness, they fell in order to begin.* Cat. 56.

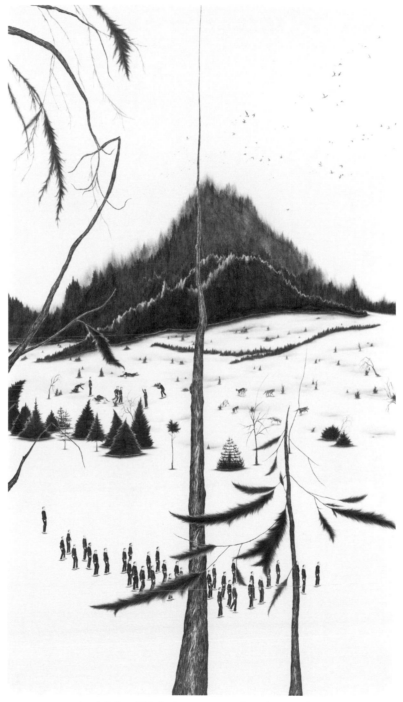

| 29 | Robyn O'Neil, *These Moving Bodies, These Numb Processions*. Cat. 57.

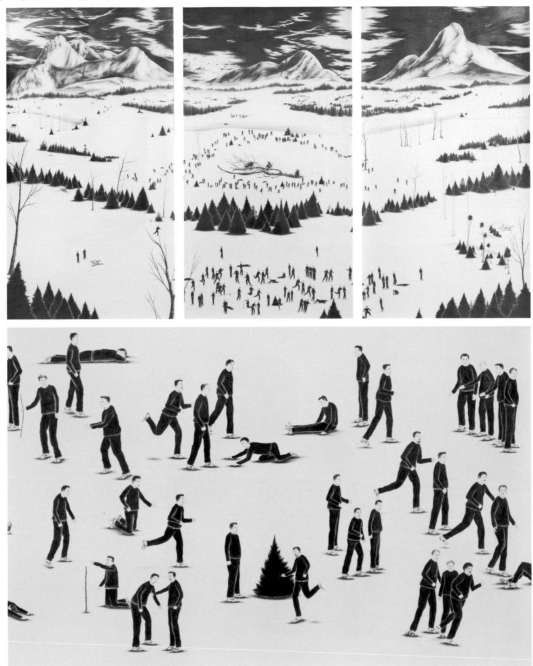

| 31 | Robyn O'Neil, *Everything that stands will be at odds with its neighbor, and everything that falls will perish without grace* (detail). Cat. 53.

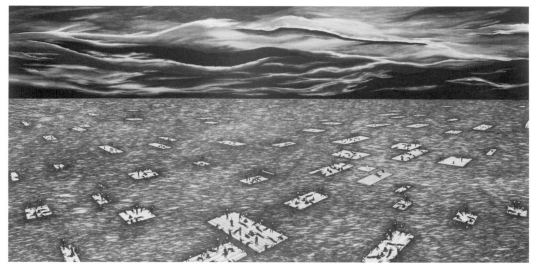

| 32 | Robyn O'Neil, *Masses and masses rove a darkened pool; never is there laughter on this ship of fools.* Cat. 54.

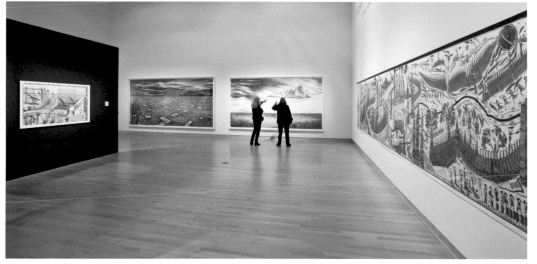

| 33 | Installation view of *Chris Hipkiss and Robyn O'Neil: A Chill in the Air.*

Carol Prusa | Optic Nerve
Amy Chaloupka

--

The optic nerve is responsible for transmitting visual information from the retina to the brain. The anatomical functionality of the optic nerve is difficult to fully apprehend—it is hard *not* to believe that something truly magical occurs along that meandering pathway from sight to understanding. In *Optic Nerve*, Carol Prusa explores the intangible connections between beauty, mystery, and science.

Webbed with intricate and softly rendered drawings in silverpoint, Prusa's orbs seem to describe the empirical labyrinth of science and mathematics, yet the emotions they summon belong to realms spiritual and poetic. The artist explains that she feels most comfortable in those places between searching and understanding, formation and dissolution, obfuscation and revelation.

Since childhood, Prusa hungered to comprehend the functionality of things— why all things are the way they are. Her drive to explore theories of everything imaginable led her into the linear fields of math and chemistry, where she studied biocommunications and medical illustration. Along this path, Prusa has dissected the human body and is intimately familiar with the astounding palettes, textures, and patterns of its inner workings. She has observed miniscule worlds under extreme magnification and transformed this complex and confounding information into two-dimensional renderings from which medical practitioners can learn.

Although this foundation equipped Prusa with a broad knowledge of the sciences, she discovered that merely translating what was before her very eyes was not enough; she longed to draw what she *wanted* to see. This revelation led Prusa to an exploration of thought and practice that would set her apart.

The labor-intensive process that characterizes Prusa's work today begins with specifically manufactured acrylic domes—some bowl-size, others upward of six feet in diameter. After preparing them with carefully applied and sanded layers of gesso, the artist intricately details the hemispheres with fine silverpoint. An ancient technique popular in the early Renaissance, silverpoint involves the use of a silver-tipped stylus. Its qualities include a delicate line that will not fade or smudge, and a shimmery luster that occurs when the traces of metal left on the textured surface oxidize.

Following this meticulous treatment, Prusa coats her domes with a graphite wash, almost obliterating the elaborate drawing beneath. Next, she retrieves

the buried underdrawing by applying a titanium white pigment in select areas, breathing life back into her initial compositions and again elevating the most essential features of the silverpoint. The last phase involves the methodical perforation of the detailed domes for the careful insertion of fiber optics and video projection. The resulting constellations softly pulsate in and around the lacey silverpoint renderings; the outcome is a synergy of ancient technique and contemporary technologies. Prusa's sculptures can take more than seven hundred hours to complete, something she describes as a personal commitment to a deeply meditative process.

For Prusa, the impetus for drawing on dome structures and employing the archaic and time-consuming process of silverpoint originated in the summer of 2002, when she taught a class on historical materials and methods in Florence, Italy. While there, she viewed some of the earliest examples of silverpoint by Old Masters in the Uffizi drawing galleries. Prusa had ready access to the media through a local supplier, which gave her the opportunity to experiment with the process. She did so in a manner vastly different from that of the realistic portraiture characterized by her Renaissance-era predecessors.

Traveling throughout Italy and Spain at that time, Prusa was also awestruck by the majesty and complexity of architectural domes—cathedrals built as containers of knowledge both spiritual and secular. Moved by these all-encompassing "domes of heaven," Prusa now seeks to evoke, from her orbs, a similarly wide

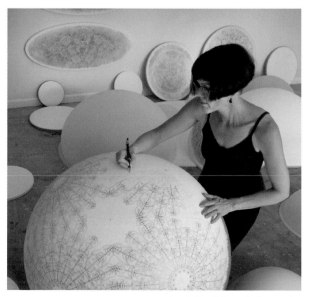

| 34 | Carol Prusa in her studio.

range of symbolisms: pregnant bellies swollen with new life, celestial bodies and expansive cosmologies, the internal workings of the human mind, cellular discoveries in petri dishes, and the elegant geometries of botanical blooms and sacred mandalas.

It can be argued that science is a quest for absolute truth while art is a creative commitment to continuedquestioning. Prusa's artwork embodies a fluid and seamless dialogue between the two. Drawn time and again to the governing theories and essential building blocks that structure our universe, Prusa diverges from a complete acceptance of quantifiable explanation.

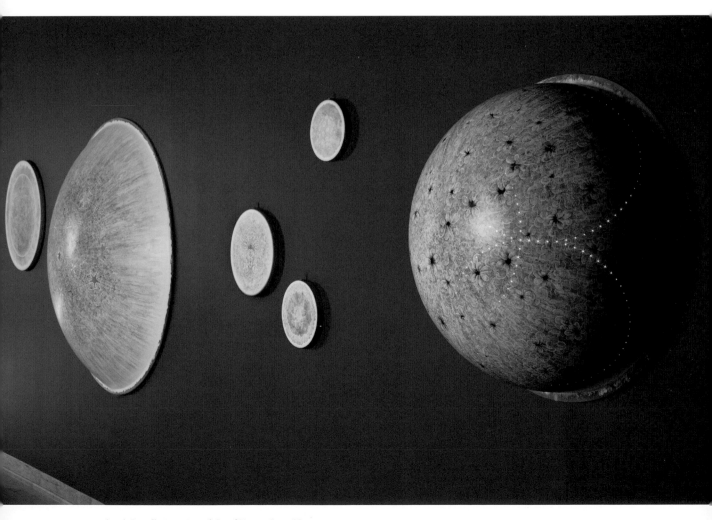

| 35 | Installation view of *Carol Prusa: Optic Nerve.*

By incorporating an intuitive and somewhat uncontrolled process in her work, Prusa remains open to possibility and flux, stating that she "yearns to create a radical vision, taking into account the chaotic interactions of the formation of the universe, while critiquing claims of truth and fully embracing mystery."[1] Like the murky graphite washes that threaten to obscure her precise silverpoint line work just underneath, Prusa delights in the infinite shades of grey—preferring subtleties and possibilities over certainties and solutions.

Note

1. Quoted from the artist in "Artists to Watch," *The Art Economist 1*, no. 5, 2011: 67.

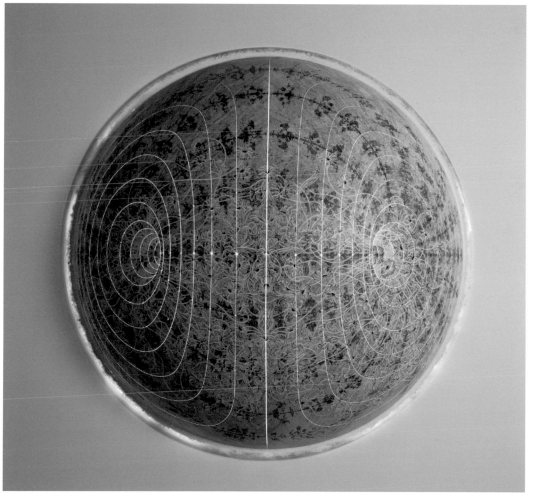

| 36 | *Bridge*. Cat 63.

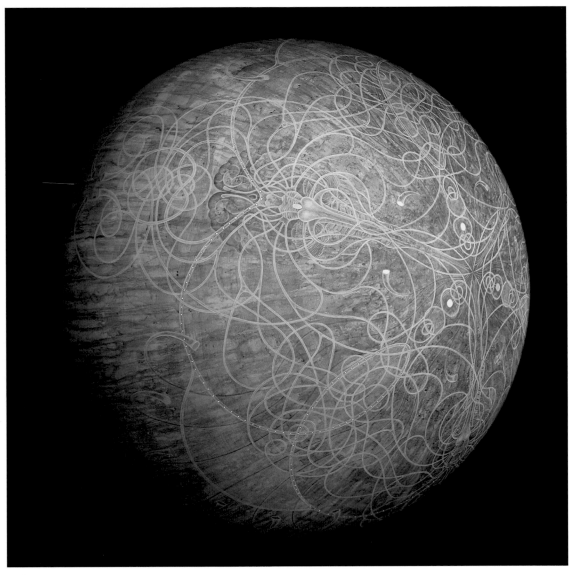

| 37 | *Optic Nerve*. Cat 78.

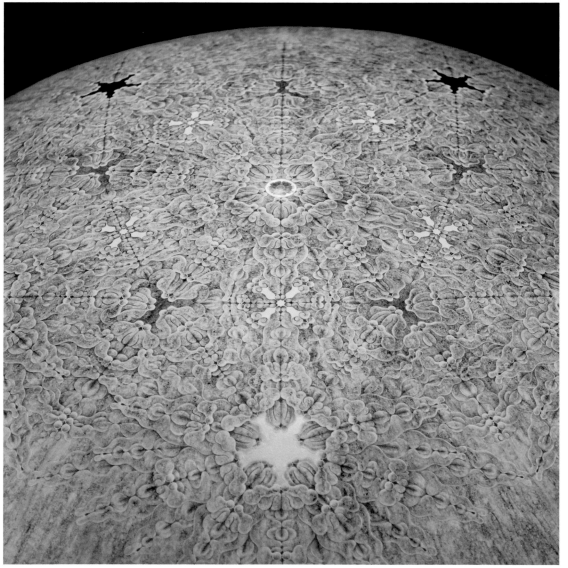

| 38 | *Pentacle.* Cat 80.

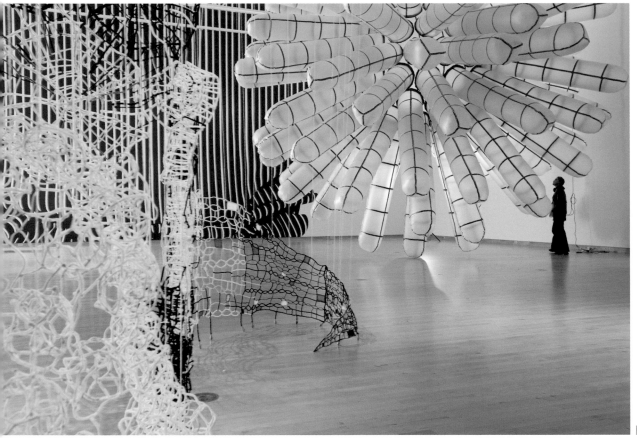

The Line *Unleashed*

installations by Alison Ferris

Dave Eppley
Anna Hepler
Caroline Lathan-Stiefel
Rita MacDonald
Heeseop Yoon

An unexpected display of fireworks lit up the sky over Lake Michigan on September 15, 2011, following a daylong site visit by five artists to the John Michael Kohler Arts Center. That day, Dave Eppley, Anna Hepler, Caroline Lathan-Stiefel, Rita MacDonald, and Heeseop Yoon began to envision the unique installations they would make at the Arts Center as well as imagine how their works would interact in the main gallery. It was a day of creative consideration, conversation, and collaboration. The sky, lit up as it was by fleeting shapes, lines, and colors, seemed, in hindsight, to be a premonition of sorts, perhaps a prequel to the works the artists would create for *The Line Unleashed*.

Each of these artists has previously examined line as a phenomenon. Their artistic pursuits have, for years, consisted of examining this essential feature of drawing. They share an interest in problems related to drawing as well as approaches for investigating those problems—ambitious and dynamic large-scale installations. These affinities led to the Arts Center's commission of new installations for *The Line Unleashed*.

Historically, drawing is not a practice in which one finds innovation, primarily because it is one of the first skills taught when preparing to become an artist. For centuries, aspiring artists spent hours practicing their drawing, most often rendering still lifes and the human figure, in preparation for realistically representing the tangible world in their art. In the early twentieth century, artists challenged the notion that the pinnacle of artistic achievement was to portray the world accurately. Furthermore, they questioned the value and sincerity of this pursuit, noting that in order to represent the visual complexities of space, viewers must agree to suspend disbelief, for instance, when standing before the receding depth in a landscape painting.

In search of visual purity or spiritual truth, twentieth-century artists decided instead to isolate and simplify elements of drawing's vocabulary at the same time that they called into question drawing's veracity. Although line was considered neutral to modern artists, it continued to allude to notions of rationalism and progression and broader Modernist concepts such as essence, universalism, and transcendence.

As the twenty-first century begins, artists from all disciplines are reevaluating art's building blocks minus the lofty goals of Modernism. Once sidelined from innovation and imagination, drawing is now central to it and, by extension, line, too, is allowed greater latitude. Now that drawing is released from its responsibility to representational art and the ideologies of modern art, artists find it liberating. The five artists in *The Line Unleashed* embrace the new openness, inventively freeing the drawn line from the confines of the picture plane and releasing it into space.

Dave Eppley | Loom

Dave Eppley's colorful lines accrue and stratify as they stray from the organizing panel that inspired the title of *Loom*. The artist Paul Klee (1879–1940) once noted that a point shifting into a line is "an active line on a walk, moving freely, without a goal. A walk for a walk's sake."[1] Eppley's lines indeed seem to be taking a walk, yet they do seem to have a goal—to escape the gallery, which is perhaps the ultimate container of lines in art. The lines from *Loom* boldly charge into, and even overtake, the public space of the Arts Center Atrium, challenging the ideas that drawing is created and experienced privately. Eppley's lines also disrupt the historical hierarchy of art that places architecture at the top and drawing near the bottom.

Viewers witness the lines going down the drains of a water fountain and up into circular air vents, encircling light sockets and fire alarms, and outlining the edges of pamphlets interleaving the reception desk shelves. Eppley's curious lines suggest larger issues of connectivity as they snake through the Atrium space, highlighting disparate, unacknowledged spaces and objects. His lines encourage physical as well as visual participation. Children understand the invitation to join in right away, walking and dancing on the lines throughout the Atrium, teetering as if they were balancing on a tightrope. *Loom*'s visual effects and underlying connotations might best be summarized in Wassily Kandinsky's (1866–1944) statement that "line is an imprint of energy—the visible trace of the invisible."[2]

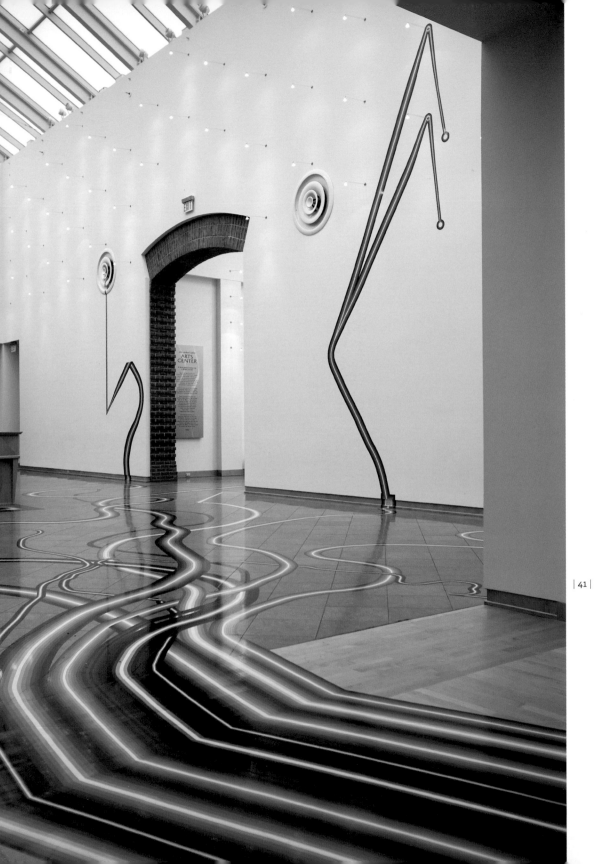

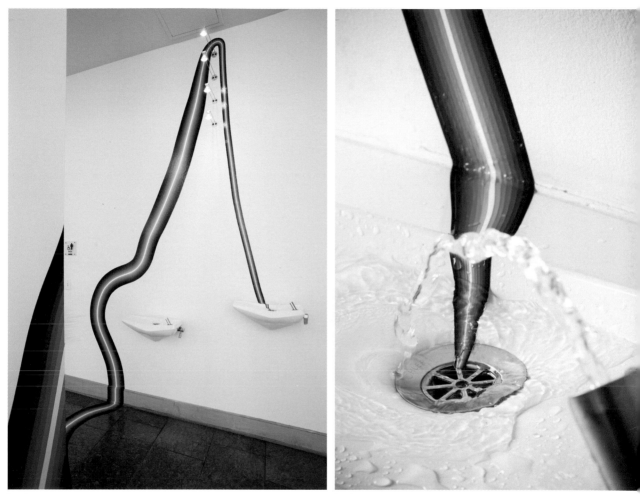

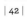

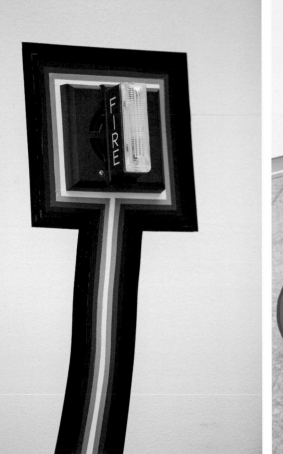

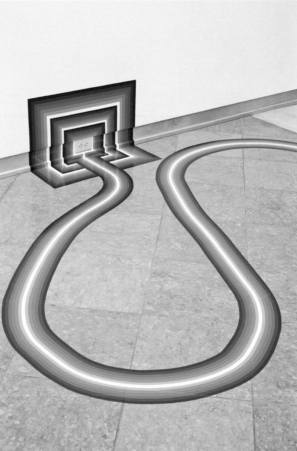

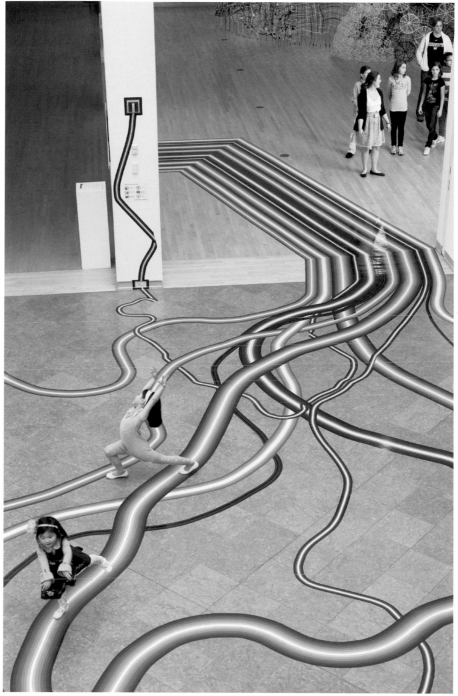

Rita MacDonald | Heap

Rita MacDonald's 24- by 34-foot wall drawing, *Heap*, is a magnificent descent of red and white stripes. In one decisive, grand gesture, the curtain-like array seems to unfurl from the very top of the wall and crumple, as the title tells us, in a heap at the floor. The gallery itself appears to enter into the cascade, as the white stripes equal the width and color of the ceiling's metal armature.

MacDonald first began observing the nature of line in the plaids of her Catholic-school uniforms. Something as simple as the swish of a skirt disrupted the continuous lines and the regular grids. In *Heap*, MacDonald examines the same phenomenon on a large scale. Line, a seemingly neutral and straightforward signifier of formal control and order, visually collapses when even the notion of a physical interruption is introduced. Furthering the complexity of MacDonald's exploration is her choice of bold red. Employing a color associated with passion and emotion, she undermines the line's ability to remain cool, practical, and neutral. In the end, *Heap* unites the stoic line of Modernism with the depth and layers of the everyday.

47

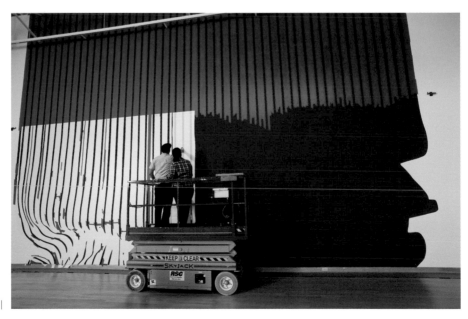

48

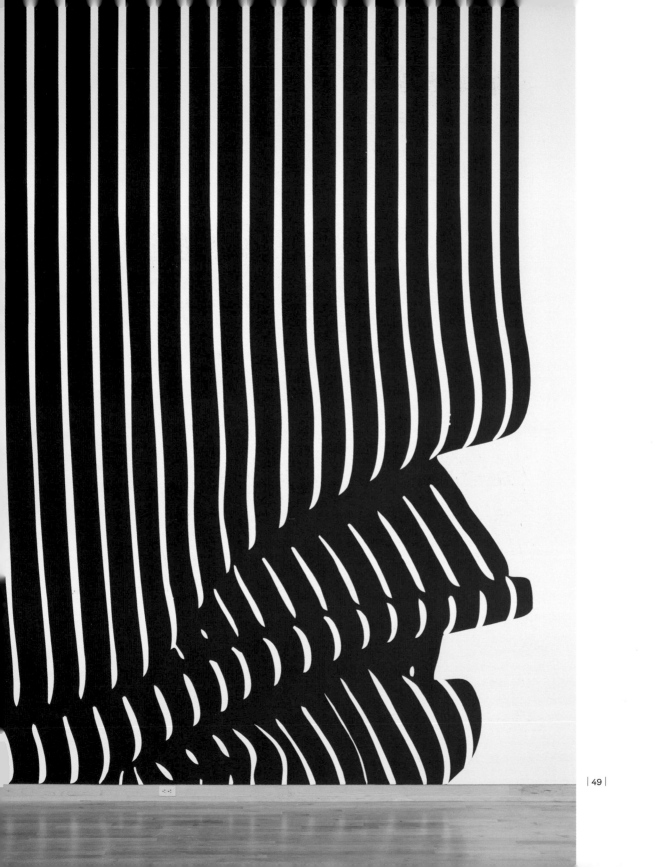

| 50 |

| 51 |

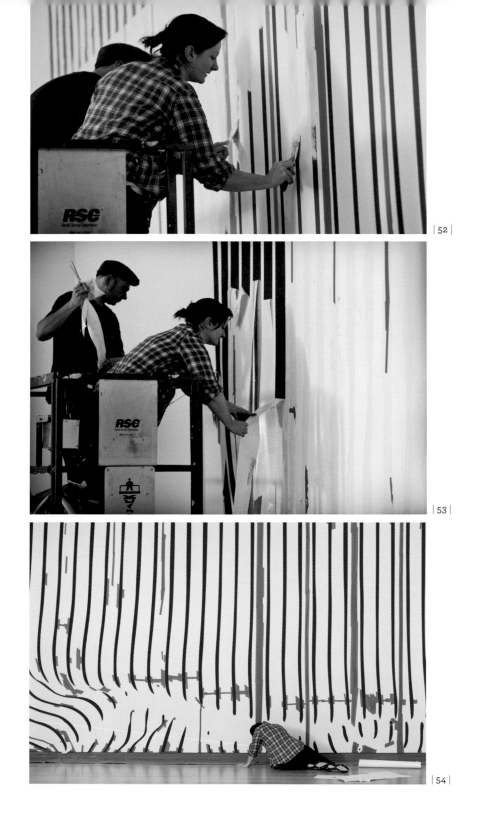

| 52 |

| 53 |

| 54 |

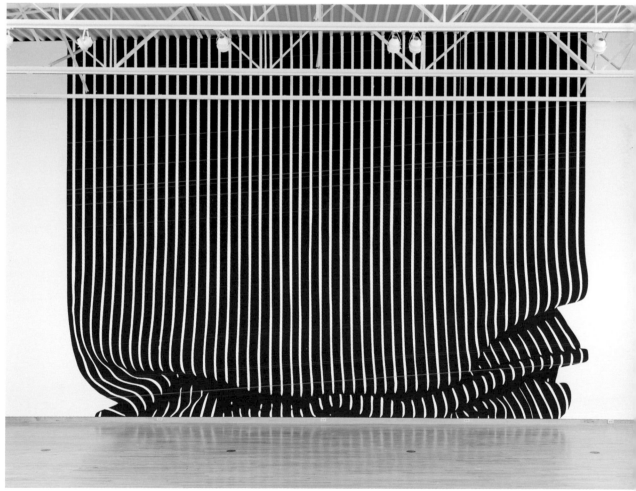

Anna Hepler | Collapse

Using what she describes as an intuitive geometry, Anna Hepler has long investigated the intersections of line and space. Turning her interests now to the three-dimensional, in *Collapse*, Hepler stitched together translucent white plastic bags to create a structure, 24 feet in diameter, that slowly inflates and deflates during a thirty-minute cycle. Hepler describes this work as, at once, a sculptural diagram and a spatial drawing. She writes: "Like a living thing, *Collapse* is restless in its ever-shifting form and in the transition it undergoes between a kind of linear chaos (when the piece is deflated) and sublime geometry (when it reaches full inflation). The title comes from that moment when the blower shuts off and the form exhales, collapsing into twisted and overlapping lines." While the sculpture sighs air, the crinkling plastic sounds like lightly pattering rain; the resulting aural poetry contributes to notions of the ephemeral evoked by the work.

Overlaying *Collapse*'s organic shape is a black grid made with packing tape that reinforces the sewn seams. In addition to binding the work together, the pattern references Modernism's reverence of the grid: the ultimate in rational organizational structures. Clearly handmade, expressive, and anything but rigid, *Collapse* effectively undermines the formality of the grid and defines "linear" on new terms. It captures theorist Gilles Deleuze's concept of lines that escape geometry—"fugitives from geometricization."[3] Art historian Briony Fer writes, "Outside the realm of perspective, the fugitive line becomes that which constructs and escapes the system as lifelines from a commodity culture predicated on obsolescence."[4] While inspired by geometry, Helper's grid ultimately fails to function as an accurate measuring system, which is precisely the point. Likewise, her shopping bags filled with nothing but air point to another type of futility. Together, these notions could be understood as a move toward reimaging the art object as something that, as Fer describes, "embraces the infinite but resists becoming a totality."[5]

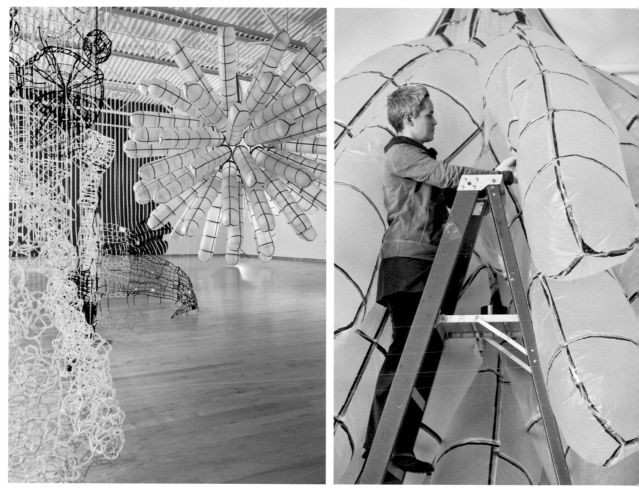

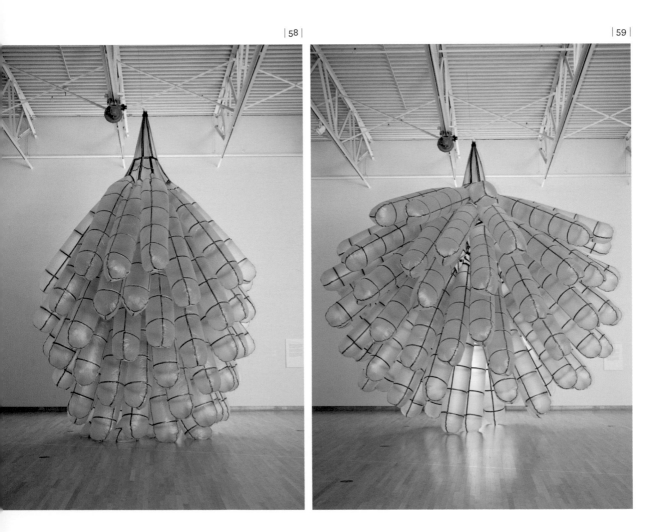

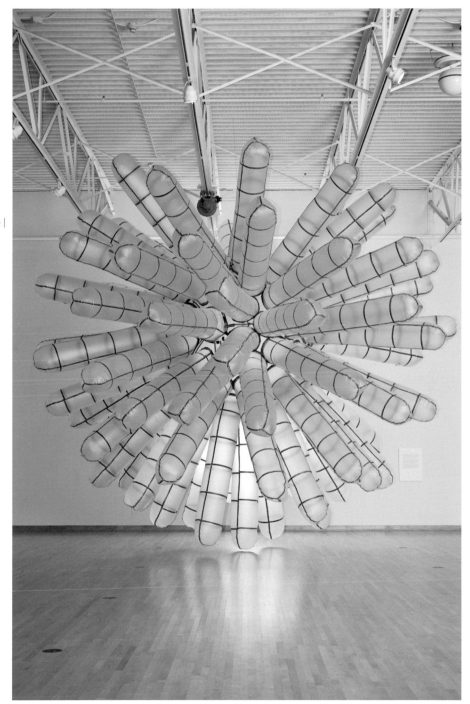

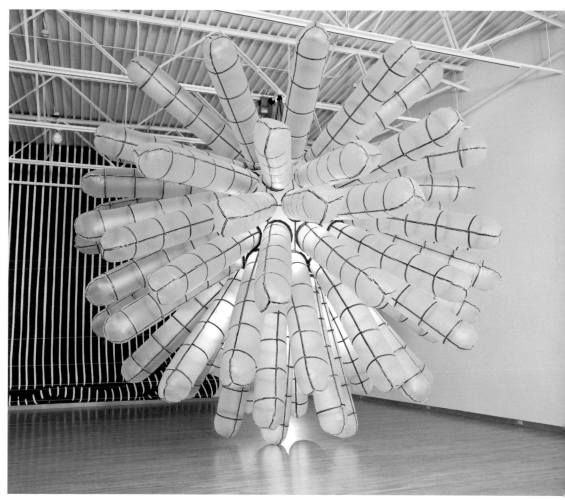

Caroline Lathan-Stiefel | *Acanthus Climbing*

Caroline Lathan-Stiefel's *Acanthus Climbing* is a serpentine trellis that hangs suspended from the ceiling. Made of black, white, yellow, and gray pipe cleaners and yarn, it measures 20 by 40 by 71 feet, extending from the northwest corner to the center of the gallery. Its woven form is weblike in some sections of the trellis and configured as loose grids in others, ultimately conflating the mathematical and the organic. All of the lines, pipe cleaners and yarn, are twisted together in a spider-like manner. The gravity-bound lines, or the warps, are anchored with fishing weights. The weft is sporadically woven through the warp, and the empty spaces are intermittently patched, in a rhythmic pattern, with scraps of fabric, plastic bags, and window screening. The materials are secured, albeit in a manner that is impermanent, with straight pins. Lathan-Stiefel describes her work as "drawings-in-space." She writes: "My work involves both the slow, plodding movement of patching pieces of cloth and plastic to linear structures made of pipe cleaners, as well as quicker, more gestural actions that connect all of the parts into systems, making large suspended sculptures."

In *Acanthus Climbing*, Lathan-Stiefel references the Mediterranean plant exquisitely carved and presented on the capitals of Greek Corinthian columns. Offering something antithetical to such chiseled perfection, it can be said that the artist celebrates a democratizing artistic process called "deskilling." This is a conscious rejection of the mastery of a traditional medium or craft such as carving sculptures from marble or drawing realistically from life. In doing so, Lathan-Stiefel deflects attention from outmoded issues of artistic genius and instead, highlights the infinite, imaginative possibilities of the line.

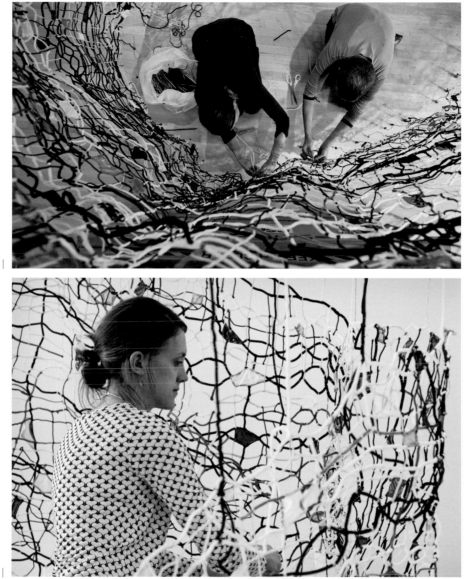

| 67 |

| 68 |

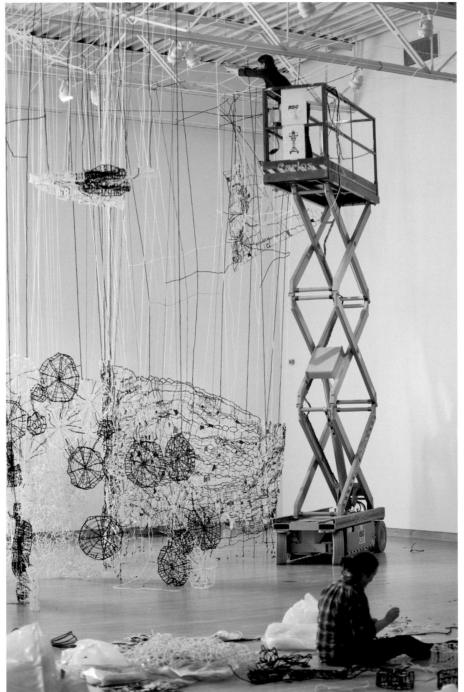

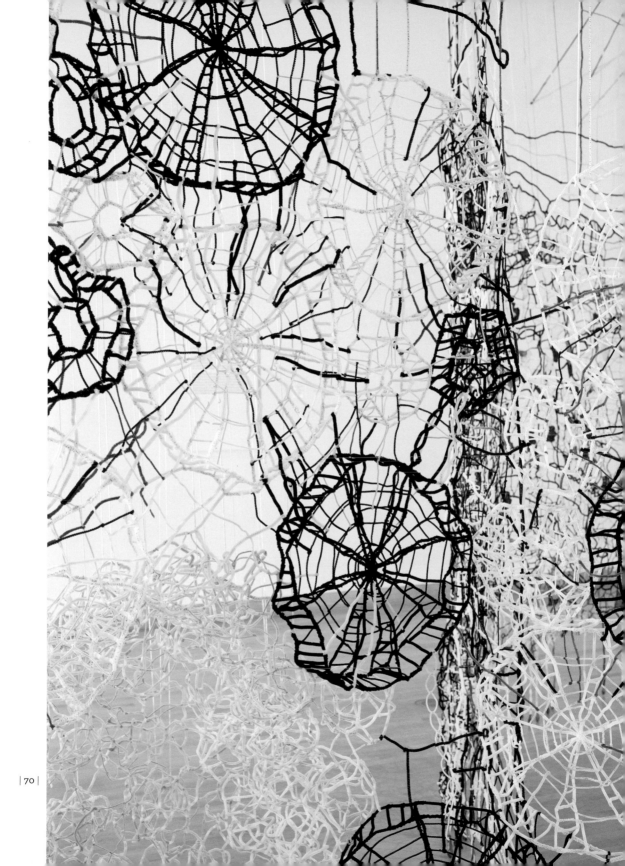

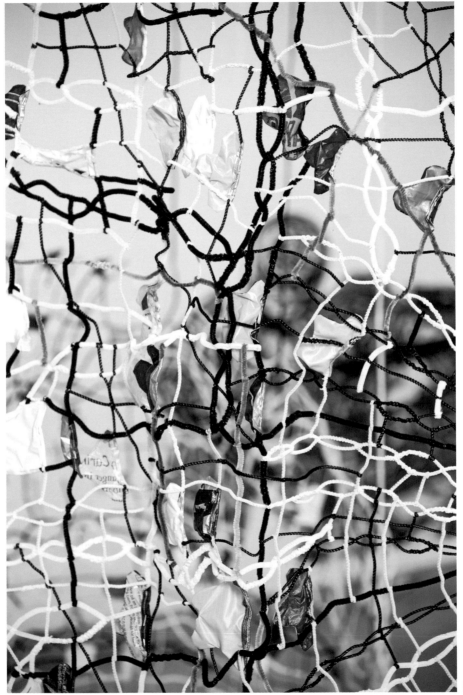

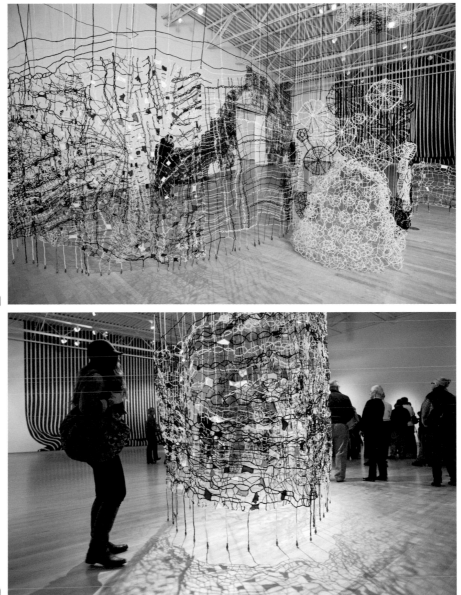

| 72 |

| 73 |

Heeseop Yoon | Still-life #12

Working from collaged photographs, Heeseop Yoon "draws" her subject matter freehand with tape on sheets of transparent polyester film that are later attached to the wall. At the Arts Center, she chose to work on a wall with a wide entrance leading to the next gallery space. Using her superior skills as a draftsman and the tools of perspective, Yoon transformed the manner in which we see the doorway—skewing the angles. A table is drawn over the door; the negative space under the table is actually the entrance into the next gallery. It appears to tip over the doorway and further affects the perspective of the real doorway. Viewers can get lost in marveling at surprises and optical illusions found throughout this intricate drawing.

Yoon uses "organizational lines" and narrow black masking tape to explore concepts of perception in *Still-life #12*. Organizational lines are used to map the structure of a realistic drawing. These lines, by definition, are drawn and later erased, but they serve to measure the composition and guide the proportional adjustment of represented objects. Yoon's subjects—interiors of junk shops and storage facilities—test the ability of the line to make order out chaos.

Yoon retains her exploratory sketches, her mistakes, and the corrections on each drawing. The lines not only situate the forms in the clutter, they also cross over, search out, and assess the entire scene. Each and every line, including the mistakes, becomes indelible when the black tape manifests its path. The multiple lines, made uniform by the one-quarter-inch tape, take on a kinetic effect and sense of immediacy. They work together to make the image less clear; the lines themselves become the subject of her drawing, more so than the objects she depicts. The resulting paradox interests Yoon: the more she looks, the less she believes in the accuracy or reality of the drawn images.

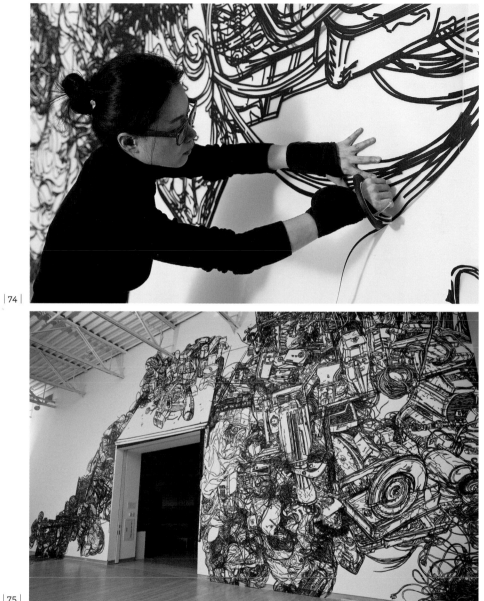

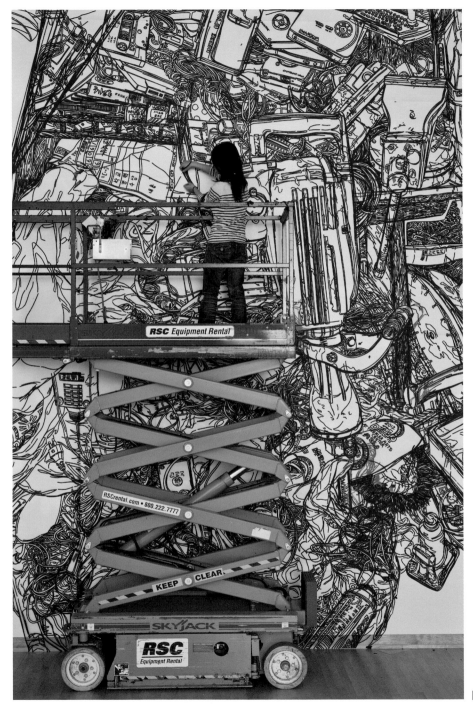

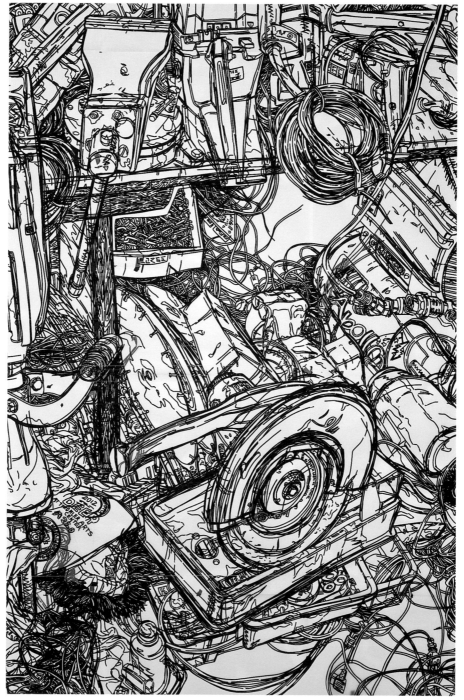

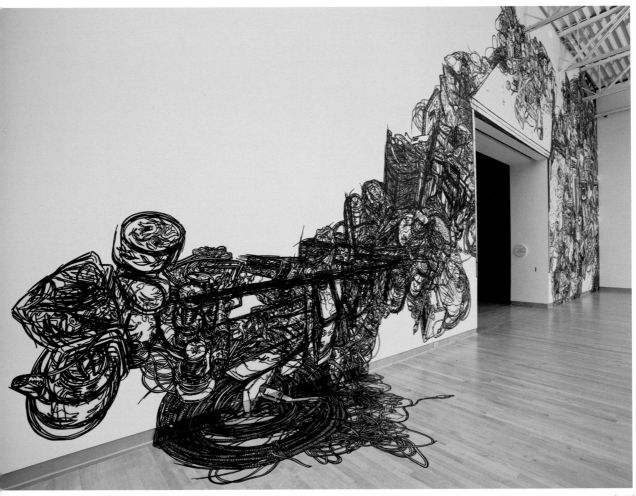

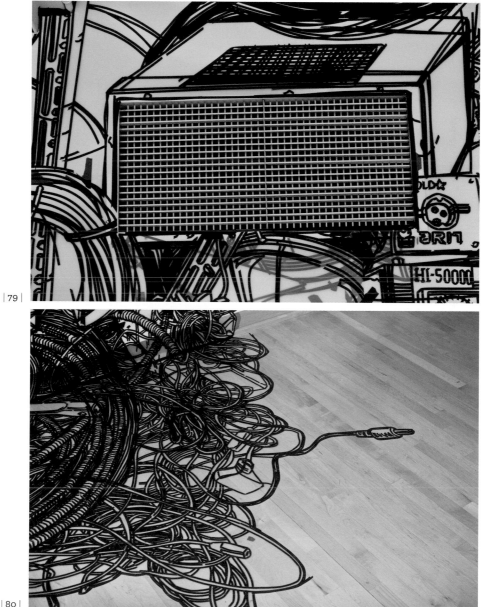

Conclusion

In challenging assumptions and universal notions about the line, the artists in *The Line Unleashed* decided to use materials that are humble in nature and methods that emphasize the labor entailed in making the art. Curators, critics, and scholars are taking note that artists today have a combined interest in materials, time, and space. The term "analog" is frequently used to describe this phenomenon, especially in terms of the renewed interest in drawing. Museum of Modern Art Curator Connie Butler writes, "I want to propose a notion of what I am calling the extreme analog of the present.... Though not directly reacting to digital-age attention deficits, these artists are formulating a practice of the everyday that refigures the consciousness of the viewer, focusing on line, time, space—a radical return."[6] Boston Institute of Contemporary Art Curator Helen Molesworth writes, "In our increasingly digitally mediated world, many [artists] have embraced a lo-fi, analog mode of working, through which they can articulate the ineffable character of human emotions, memory, and history in a distinctly nonverbal manner."[7]

While none of the artists in *The Line Unleashed* entirely reject the technological transition our society is experiencing, they certainly do provide an occasion to pause. Structuring the space with a connective network of lines—lifelines perhaps—they created a place to contemplate the state of our current existence. In lines that can be variously described as colorful, organic, delicate, clumsy, dense, imprecise, and strong, the artists also describe, in a larger sense, the human condition. In analog, writes Butler, "There is a relationship to the real and its infinite combinations, a notion of space which is not defined by absence but presence."[8] Likewise, the artists in *The Line Unleashed* refuse the monumental (celebrating absence) and instead, with their methods, concepts, and materials, emphasize physical presence. Eppley's title, *Loom,* presents a double entendre, a hovering presence and a structure for handweaving. Lathan-Stiefel, too, alludes to fabric, a reference punctuated by straight pins in the lattice that comprises *Acanthus Climbing.* In *Still-Life #12,* Yoon's self-conscious use of organizational line, used by artists to situate objects within a composition, denotes the physical act of drawing. MacDonald's lines transform from conceptual to the material when they hit the floor in *Heap.* Finally, Hepler's *Collapse* challenges the very foundation of structure and form.

The Arts Center has long prided itself on supporting projects in which the creation of art is not only visible but shared.[9] Likewise, the artists in *The Line Unleashed* forge a link with their audience by employing modest materials and revealing the means of labor; it is an invitation to visually participate in their creations. The lines made accessible, in turn, become themselves unfettered, and acknowledging the significance of line, these artists allow them great expanse. Finally, reminiscent of the fireworks on that September evening, and like drawing, and like human life itself, the works of art in *The Line Unleashed* are ephemeral. The installations exist now to inspire conversation, contemplation, and community, and then trace such lines into our own lives after they are gone.

Notes

1. Paul Klee, *Pedagogical Sketchbook*, 1925 (English translation, New York: Frederick A. Praeger, 1953), p. 16.

2. Vasily Kandinsky, "Point and Line to Plane: A Contribution to the Analysis of Pictorial Elements," 1926, in *Kandinsky: Complete Writings on Art*, ed. Kenneth C. Lindsay and Peter Vergo (New York: G.K. Hall & Co., 1982), Volume 2: p. 542.

3. Gilles Deleuze, quoted in Briony Fer, "Drawing Drawing: Agnes Martin's Infinity" in *Women Artists at the Millennium*, ed. Carol Armstrong and Catherine de Zegher (Cambridge, MA: The MIT Press, 2006), p. 176.

4. Fer, ibid.

5. Ibid.

6. Cornelia H. Butler, "Walkaround Time: Drawing and Dance in the Twentieth Century," in *On Line: Drawing through the Twentieth Century*, ed. Cornelia H. Butler and Catherine de Zegher (New York: Museum of Modern Art, 2010) p. 191.

7. Helen Molesworth, "Dance/Draw: An Introduction" in *Dance/Draw*, ed. Helen Molesworth (Ostfildern, Germany: Hatje Cantz Verlag, 2011), p. 15.

8. Marie Cool and Fabio Balducci quoted in Cornelia H. Butler, "Walkaround Time: Drawing and Dance in the Twentieth Century," in *On Line: Drawing through the Twentieth Century*, ed. Cornelia H. Butler and Catherine de Zegher (New York: Museum of Modern Art, 2010) p. 200.

9. When the artists returned in February 2012, the doors of the main gallery were left open for visitors to watch as the artists installed their work.

CATALOGUE OF WORKS

Height precedes width precedes depth.

PAUL CHIAPPE AND PEGGY PREHEIM: QUIET ACCORD
PAUL CHIAPPE

1. *Dean Orphanage*, 2009
 pencil on paper; paper: 13 x 14 3/4 in.; image: 6 x 7 15/16 in.
 Collection of Lea Weingarten, TX
2. untitled, 2005
 pencil on paper; paper: 22 1/2 x 30 in.; image: 3 3/8 x 5 3/8 in.
 Collection of Hamilton Corporate Finance Ltd.
3. *Untitled 1*, 2003
 pencil on paper; paper: 15 1/2 x 12 in.; image: 5 1/8 x 7 1/2 in.
 Collection of Hamilton Corporate Finance Ltd.
4. *Untitled 11*, 2009
 pencil on paper; paper: 8 1/2 x 12 7/8 in.; image: 1 15/16 x 2 5/8 in.
 Courtesy of Madder139, U.K.
5. *Untitled 27*, 2008
 paint and pencil on paper; paper: 8 1/2 x 7 5/8 in.; image:
 1 1/8 x 1 1/2 in.
 Collection of Nate Kacew, NY
6. *Untitled 34*, 2009
 pencil on paper; paper: 6 1/8 x 5 7/8 in.; image: 15/16 x 1 1/2 in.
 Collection of Jennifer Butkevich, TX
7. *Untitled 36*, 2009
 pencil and paint on paper; paper: 5 3/4 x 5 3/4 in.; image:
 1 11/16 x 2 5/16 in.
 Collection of Deborah Goodman Davis, NY
8. *Untitled 45*, 2010
 pencil on paper; paper: 6 1/2 x 5 1/4 in.; image: 1 1/4 x 7/8 in.
 Private Collection, London

PEGGY PREHEIM
All works courtesy of the artist and Tanya Bonakdar Gallery, NY

9. *The Astronomer*, 2010
 pencil on paper; 22 x 30 in.
10. *Bee in the Bonnet*, 2009
 pencil on paper; 22 x 30 1/4 in.
11. *Buffalo Bill*, 2009
 pencil and banknote on paper; 22 x 30 1/4 in.
12. *Fourth Coming*, 2009
 pencil on paper; 22 x 30 1/4 in.
13. *Grass Ceiling*, 2008
 pencil on paper; 22 x 30 1/4 in.
14. *Hair Trigger*, 2008
 pencil on paper; 14 x 11 in.
15. *Last Man Standing*, 2009
 pencil and banknote on paper; 22 x 30 1/4 in.
16. *Little Princess*, 2008
 pencil on paper; 22 x 30 1/4 in.
17. *Miss Match*, 2008
 pencil on paper; 22 x 30 1/4 in.
18. *Plait*, 2007
 pencil on paper; 14 x 11 in.
19. *Point Blank*, 2009
 pencil on paper; 22 x 30 1/4 in.
20. *Triple Crown*, 2007
 pencil on paper; 14 x 11 in.
21. *Zodiac*, 2008
 pencil on paper; 11 x 8 1/2 in.

**TIMOTHY WEHRLE: I DON'T UNDERSTAND YOU
AND I NEVER WILL**

22. *Anytime Heartland Shopping*, 2008
 colored pencil and graphite on paper; 8 1/4 x 12 3/4 in.
 Collection of Timothy S. Garvey, IL
23. *Be Quiet, Don't Move, Watch the Beauty While it's Still in Front
 of You*, 2011
 colored pencil and graphite on paper; 38 x 25 in.
 Courtesy of Cavin-Morris Gallery, NY
24. *Believable Households*, 2010
 colored pencil and graphite on paper; 10 works: 18 x 15 in. ea.
 John Michael Kohler Arts Center Collection
25. *Culdesacs, Oooh How They Twinkle Throughout the Night*, 2007
 colored pencil on newsprint; 24 x 25 1/4 in.
 Collection of Jean de Segonzac and Jane Bohan, NY
26. *Different Car Same Sweet Dream*, 2007
 collage, graphite, walnut ink, watercolor, on paper; 8 x 10 1/2 in.
 Collection of Martina Batan, NY

27. *8 of 12 Entrances of Old Man Winter*, 2007
 colored pencil and graphite on paper; 6 1/8 x 8 1/4 in.
 Collection of John H. Friedman, NY
28. *11 of 12 Entrances of Old Man Winter*, 2007
 colored pencil and graphite on paper; 6 1/8 x 8 1/4 in.
 Collection of John H. Friedman, NY
29. *5 of 12 Entrances of Old Man Winter*, 2007
 colored pencil and graphite on paper; 6 1/8 x 8 1/4 in.
 Collection of Siri Von Reis, NY
30. *4 of 12 Entrances of Old Man Winter*, 2007
 colored pencil and graphite on paper; 6 1/8 x 8 1/4 in.
 Collection of Siri Von Reis, NY
31. *The Hypnotist*, 2008
 colored pencil and graphite on paper; 25 x 38 in.
 Collection of John and Susan Jerit, TN
32. *I Don't Understand You and I Never Will*, 2011
 colored pencil and graphite on paper; 25 x 25 in.
 Collection of Audrey B. Heckler, NY
33. *In the Box*, 2011
 colored pencil and graphite on paper; 20 x 20 in.
 Courtesy of Cavin-Morris Gallery, NY
34. *Men's Menstrual Cycle*, 2006
 colored pencil, graphite, walnut ink on wood; 24 x 24 in.
 Collection of Audrey B. Heckler, NY
35. *My Grandfather's 80th Birthday Dance Party
 at the Moose Lodge*, 2010
 colored pencil and graphite on paper; 24 3/4 x 38 in.
 Collection of John and Susan Jerit, TN
36. *New Breed Attending the Fair for Human Struggle*, 2007
 colored pencil on paper; 25 x 58 in.
 Collection of Audrey B. Heckler, NY
37. *The New Caucasian Crusade at The Moxibustion
 Clinic*, 2008
 graphite, walnut ink, watercolor on paper; 31 x 41 1/4 in.
 Collection of Audrey B. Heckler, NY
38. *9 of 12 Entrances of Old Man Winter*, 2007
 colored pencil and graphite on paper; 6 1/8 x 8 1/4 in.
 Collection of Martina Batan, NY
39. *1 of 12 Entrances of Old Man Winter*, 2007
 colored pencil and graphite on paper; 6 1/8 x 8 1/4 in.
 Collection of Elizabeth Stern, NY
40. *Self-portrait of the Artist Reflecting Back on
 a Reflection*, 2009
 colored pencil and graphite on paper; 25 x 38 in.
 Collection of John Zorn, NY
41. *3 of 12 Entrances of Old Man Winter*, 2007
 colored pencil and graphite on paper; 6 1/8 x 8 1/4 in.
 Collection of Elizabeth Stern, NY
42. *12 of 12 Entrances of Old Man Winter*, 2007
 colored pencil and graphite on paper; 6 1/8 x 8 1/4 in.
 Collection of Selig D. Sacks, NY
43. *The Unbreakable Chain, the Human Mission to Pass
 Down the Untarnishable Book of Fetish Part 1*, 2009
 colored pencil and graphite on paper; 38 x 25 in.
 Collection of Mark Pollack, NY

LAYLAH ALI: NOTE DRAWINGS

44. *Note Drawings*, 2008
 colored pencil, gouache, ink on paper; 12 drawings:
 10 x 7 1/4 in. ea.; 27 drawings: 11 x 8 1/2 in. ea.
 Courtesy of the artist and Ellen Miller Gallery, MA

**CHRIS HIPKISS AND ROBYN O'NEIL:
A CHILL IN THE AIR**
CHRIS HIPKISS

45. *A Lucy for the Threes*, 2004
 graphite on paper; 58 x 36 in.
 Collection of Audrey B. Heckler, NY
46. *Afraid That I Shant*, 2006
 graphite and ink on paper; 55 1/2 x 31 1/2 in.
 Collection of Elizabeth Stern, NY
47. *Lonely Europe Arm Yourself*, 1995
 graphite and silver ink on paper; 5 x 35 in.
 John Michael Kohler Arts Center Collection
48. *Mongrel Global 37 (Fist After the War)*, 1997
 graphite and silver ink on paper; 55 1/8 x 152 in.
 John Michael Kohler Arts Center Collection

49. *My Sea Induced Crime*, 1995
 graphite and silver ink on paper; 31 x 64 in.
 John Michael Kohler Arts Center Collection
50. *Our Slit With The South*, 2004
 graphite on paper; 36 1/4 x 59 in.
 Courtesy of Cavin-Morris Gallery, NY
51. *Wolfe & Stole Inc.*, 2010
 graphite on paper; 23 1/2 x 33 3/4 in.
 Courtesy of Cavin-Morris Gallery, NY

ROBYN O'NEIL
52. *A death, a fall, a march: toward a better world*, 2008
 graphite on paper; 32 x 40 in.
 Collection George Morton and Karol Howard, TX
53. *Everything that stands will be at odds with its neighbor,
 and everything that falls will perish without grace*, 2003
 graphite on paper; 94 1/2 x 162 1/2 in.
 Blanton Museum of Art, The University of Texas at
 Austin, Collection of Jeanne and Michael Klein and the
 Jack S. Blanton Museum of Art, fractional and pledged
 gift, 2004
54. *Masses and masses rove a darkened pool; never is there
 laughter on this ship of fools*, 2007
 graphite on paper; 79 3/4 x 161 1/8 in.
 Collection of the Kemper Museum of Contemporary Art,
 Kansas City, Missouri. Museum Purchase made possible
 by a gift from the Kearney Wornall Foundation, 2007.3
55. *Oh, How the heartless haunt us all*, 2005
 graphite on paper; 82 8/9 x 66 in.
 Collection of Anthony Terrana, MA
56. *Staring into the blankness, they fell in order to begin*, 2008
 graphite on paper; 76 1/2 x 144 in.
 Linda Pace Foundation Collection
57. *These Moving Bodies, These Numb Processions*, 2005
 graphite on paper; 65 x 37 in.
 Private Collection
58. *This Seething Devotion*, 2005
 graphite on paper; 20 x 32 in.
 Collection of Tony Wight, IL

CAROL PRUSA: OPTIC NERVE
All works courtesy of Bernice Steinbaum Gallery,
Miami, FL
59. *Aglaophonos (Lovely Voices)*, 2007
 acrylic binder, graphite, pigment, silverpoint on wood;
 17 7/8 x 41 7/8 x 1 in.
60. *An Awful Rowing/Atomic Sublime*, 2007
 acrylic binder, graphite, pigment, silverpoint on wood;
 48 x 96 x 1 in.
61. *Babel*, 2007
 acrylic binder, graphite, pigment, silverpoint, sulfur on
 wood; 80 x 44 x 1 in.
62. *Between You and Me*, 2011
 acrylic binder, fiber optics, graphite, pigment, silverpoint
 on acrylic; 12 x 12 x 6 in.
63. *Bridge*, 2012
 acrylic binder, fiber optics, graphite, pigment, silverpoint
 on acrylic; 60 x 60 x 12 in.
64. *Center*, 2011
 acrylic binder, fiber optics, graphite, pigment, silverpoint
 on acrylic; 12 x 12 x 4 in.
65. *Chaosmos*, 2009
 acrylic binder, aluminum leaf, fiber optics, graphite,
 pigment, silverpoint on acrylic; 30 x 30 x 12 in.
66. *Core (Fire)*, 2006
 acrylic binder, graphite, pigment, silverpoint on wood;
 29 1/2 x 29 1/2 x 1 in.
67. *Domus*, 2011
 acrylic binder, fiber optics, graphite, pigment, silverpoint
 on acrylic; 29 x 48 x 12 in.
68. *From Me to Us*, 2005
 acrylic binder, graphite, pigment, silverpoint on wood;
 24 x 24 x 1 in.
69. *Grey Matter*, 2009
 acrylic binder, fiber optics, graphite, pigment, silverpoint
 on acrylic; 18 x 18 x 9 in.
70. *Innie*, 2005
 acrylic binder, graphite, pigment, silverpoint on wood;
 6 1/16 x 6 1/16 x 1 in.

71. *Internal Architecture*, 2009
 acrylic binder, fiber optics, glass, graphite, iPod with
 video, pigment, silverpoint on acrylic; 22 x 22 x 11 in.
72. *Latona*, 2011
 acrylic binder, fiber optics, graphite, pigment, silverpoint
 on acrylic; 30 x 30 x 15 in.
73. *Limen*, 2008
 acrylic binder, fiber optics, graphite, pigment, silverpoint
 on acrylic; 36 x 36 x 18 in.
74. *Matrix (Earth)*, 2007
 acrylic binder, graphite, pigment, silverpoint on wood;
 36 7/8 x 36 7/8 x 1 in.
75. *Monad*, 2005
 acrylic binder, graphite, pigment, silverpoint on wood;
 7 7/8 x 7 7/8 x 1 in.
76. *Mouth*, 2007
 acrylic binder, graphite, pigment, silverpoint on wood;
 12 3/8 x 12 3/8 x 1 in.
77. *Omphalos*, 2011
 acrylic binder, aluminum leaf, fiber optics, graphite,
 pigment, silverpoint on acrylic; 50 x 50 x 10 in.
78. *Optic Nerve*, 2007
 acrylic binder, fiber optics, graphite, pigment, silverpoint
 on acrylic; 36 x 36 x 18 in.
79. *Outie*, 2005
 acrylic binder, graphite, pigment, silverpoint on wood;
 6 7/8 x 6 7/8 x 1 in.
80. *Pentacle*, 2010
 acrylic binder, fiber optics, glass, graphite, iPod with
 video, pigment, silverpoint on acrylic; 50 x 50 x 10 in.
81. *Perpetual*, 2005
 acrylic binder, graphite, pigment, silverpoint on wood;
 8 7/8 x 8 7/8 x 1 in.
82. *Pharmakon*, 2007
 acrylic binder, graphite, pigment, silverpoint on wood;
 29 5/8 x 29 5/8 x 1 in.
83. *Rose (for Jay deFeo)*, 2010
 acrylic binder, fiber optics, graphite, pigment, silverpoint
 on acrylic; 50 x 50 x 10 in.
84. *Sip*, 2010
 acrylic binder, graphite, pigment, silverpoint on acrylic;
 30 x 30 x 15 in.
85. *Spooky Action at a Distance*, 2005-07
 acrylic binder, graphite, pigment, silverpoint on wood; 2
 panels: 48 x 84 ea.
86. *Threshold*, 2007
 acrylic binder, aluminum leaf, fiber optics, graphite,
 pigment, silverpoint on acrylic; 36 x 36 x 18 in.
87. *Tomb*, 2004-07
 acrylic binder, glass, graphite, pigment, silverpoint
 on wood; 80 x 44 x 1 in.
88. *Viral*, 2011
 acrylic binder, fiber optics, graphite, pigment, silverpoint
 on acrylic; 26 x 26 x 8 in.

THE LINE UNLEASHED
DAVE EPPLEY
89. *Loom*, 2012
 vinyl; 266 x 868 x 849 in.
 Courtesy of the artist

ANNA HEPLER
90. *Collapse*, 2012
 electric blower, electrical tape, plastic; 288 x 288 x 288 in.
 Courtesy of the artist

CAROLINE LATHAN-STIEFEL
91. *Acanthus Climbing*, 2012
 fabric, lead, pins, pipe cleaners, plastic, yarn;
 240 x 472 x 849 in.
 Courtesy of the artist

RITA MACDONALD
92. *Heap*, 2012
 paint and plaster; 288 x 405 in.
 Courtesy of the artist

HEESEOP YOON
93. *Still-Life #12*, 2012
 masking tape and polyester film; 276 x 586 in.
 Courtesy of the artist